# FINDING
# CALCUTTA

## MEMOIRS OF A PHOTOGRAPHER

MARIE BISSELL CONSTANTIN

Scripture texts in this work are taken from the *New American Bible, revised
edition*© 2010, 1991, 1986, 1970 Confraternity of Christian Doctrine,
Washington, D.C. and are used by permission of the copyright owner. All
Rights Reserved. No part of the New American Bible may be reproduced
in any form without permission in writing from the copyright owner.

ISBN: 978-1-4834-5478-8 (sc)
ISBN: 978-1-4834-5476-4 (hc)
ISBN: 978-1-4834-5477-1 (e)

Library of Congress Control Number: 2016911310

Unless otherwise attributed, all photos by Marie Constantin.
www.marieconstantin.com

Lulu Publishing Services rev. date: 07/14/2016

Dedicated to

## Susan Hillenbrand Herbst

Formerly Sister Charlotte Marie—A Holy Cross Sister
From South Bend, Indiana, who now lives
with her family in Rathdrum, Idaho

## Written For

Jason Carlson
Wendy Jacque
Jacob Rose
Jinx Burton
Virginia Haskins

# ACKNOWLEDGEMENTS

Readers: Carrol Bass, Elaine Crowe, Tim Basden and Alice Landry, Shar Olivier, Renee Verma, Becky Kirk, Nic Bourque. Special thanks to Sister Theresa Baldini, MM, Sister Antoinette Gutzler, MM, Sister Ellen Dabrieo, SND, Sister Janelle Sevier, SND.

## Special Thanks

These people gave me encouragement or inspiration at some point in my journey. Special thanks to Sister Marie (Mary Magdalen) Doelger, MM, Phoebe Doelger Bissell, Chelsea Waller, Mother Teresa's Sisters-the Missionaries of Charity. Sister Maria Rose, MC, Sister Sylvia, MC, Sister Ancy, MC, Sister Janita, MC. Thanks to The Franciscan Missionaries of Our Lady in Baton Rouge. Thanks to Dorothy Bissell, Janice Larimer, Lori Sheradin, David Jacque, Wendy Carlson, Bishop Robert Muench (my bishop), Father Paul Counce (my pastor), Father Johnny Carville, Tammy and Mark Abshire, Margaret Lovecraft at LSU Press, Bradley James, Michael Collopy, Alix Basden, Hugo Basden, Peter Basden, Sophie Basden, Cliff and Teresa Witte, Dallas and Vicki Ziegler, Angela and Charlie DeGravelles.

# INTRODUCTION

More than thirty years ago Mother Teresa flew into New Orleans where she was scheduled to speak to a large crowd of young people waiting in the Superdome. I drove in from Baton Rouge, Louisiana to take her picture.

I never dreamed that my 1984 encounter would mark the first of many encounters. Nor did I dare dream that two decades later one of my images would be chosen to hang in Saint Peter's Square at the Vatican to be unveiled in front of over 300,000 people for her beatification ceremony.

Several years after that first encounter, I began pursuing a religious vocation for myself, traveling to Calcutta, Tijuana, Singapore and Nicaragua—places where nuns ran soup kitchens and shelters.

Though a large part of my chronicles as a photographer and a seeker are about Mother Teresa, other Catholic nuns[1] whose stories I have included are some Holy Cross Sisters at my South Bend, Indiana boarding school; Sister Dorothy Stang, a sister of Notre Dame de Namur; Franciscan Missionaries of Our Lady, and their mission in Haiti; and the two Maryknoll Sisters, one lay missionary and one Ursuline Sister who were raped and murdered in El Salvador because of their work with the poor during civil unrest.

Because of my role as a professional photographer, I found myself being invited to travel up and down the East coast to capture Mother Teresa in rare, private moments behind the scenes, as well as document the vow ceremonies of her sisters. As a result of these invitations, I don't have images of Mother Teresa picking people up off the streets. What I have is a collection of wonderful moments captured in powerful black-and-white images, including the 2003 beatification photo.

I struggled to write this memoir because I had to come to terms with what people expected: images and stories of Mother picking people up off the streets. But I had something different. I had heartwarming stories about women religious, Catholic sisters and nuns.[1] So I decided to write a memoir for my niece and my two nephews who had no expectations of me and little knowledge of my work or whereabouts. This memoir is the result of writing for Wendy, Jason and Jake. When I got stuck, I dug deep inside of me and I wrote to them.

# CONTENTS

## CHAPTER ONE

# TURNING PORK CHOPS

**A** CLOCK TICKED ITS WAY TOWARD midnight in the convent-wing of the old mansion. That's where a long system of hallways outside my bedroom door waited in darkness for someone to travel down them.

I strained, trying to keep my mattress from crunching as I began slipping out of bed. Slowly lowering one bare foot at a time onto the wooden floor beneath me, my heels felt the floor first. Next I leaned forward, rocking my body upward into a standing position.

Making my way across the room, I paused at the threshold of my bedroom door long enough to allow the sounds of nothingness to return to the room before I ventured further.

Finally, I began slipping down the hallway ever so deliberately, quietly, almost rhythmically, like a nun moving her fingers over her rosary beads; first the left foot, now the right foot, then left, then right, left, right…now a pause…and so I continued.

Earlier trips down this same path taught me that if I placed a foot where the floor met the walls, the old oak boards lay more firmly in place and I could reduce the risk of disturbing them.

I managed to go undetected one-quarter way down the first stretch when suddenly, the wood betrayed me, giving way with one loud crack.

I froze, trying not to wobble while my heart slammed against my chest. My partner in crime up ahead froze, too.

Even though my guide, Sandy Barham, roomed at the opposite end of the horseshoe-shaped building, she had fetched me out of bed so I could join the pajama party being held in a dorm room at her end.

"Lights out" was hours ago. By now we should have been in a deep slumber. Instead, we crept down a hallway full of sleeping nuns in an all-girl's boarding school run by the Sisters of the Holy Cross in South Bend. We were just teenagers—some of us living thousands of miles away from home.

Back in 1921 the mansion had been built for the President of the Studebaker Corporation—an iconic automobile manufacturer. The architect designed the home in the style of an English manor house. The nuns acquired it in 1945—along with the 60 acres it sat on, turning it into an all-girls school.

Rumor was that a former mansion owner killed himself in one of the five bedrooms where this hallway led. Upon their arrival to boarding school, upper classmates summarily told new boarders that it was in their bedroom that he shot himself.

I should have been rooming in that section of the mansion anyway. In fact, I started out there at the beginning of the term, but mid-way into the school year, the nuns separated me from my classmates, transferring me to a small corner room on the very tip of the nun's wing—a room reserved for girls like me who were instigators of sorts.

Consequently, I was where Sister Mary of Good Counsel—the Dean of Girls at Saint Mary's Academy—could keep a closer eye on me.

Sister Mary of Good Council stood tall and tight-lipped. She had a menopausal look to her, like she was tightly wound up. When she looked at me she got a plastic smile on her face—the kind of smile you'd find on a dead body—like when a mortician tries to make the corpse look happy by jacking up the two sides of the mouth.

Whenever our wild natures disturbed her, there were no lectures or sit-down meetings, no discussion with a friendly arm around a shoulder. She would simply give a formal stare while saying, "Now, Ladies." Sister Mary of Good Council could draw out the word "l a d i e s" so slowly you'd swear she was from the Deep South. While our 15-year old minds

were anything but that of "ladies," we knew how to snap into place to give the appearance of being proper.

On the other hand, my favorite nun, Sister Charlotte Marie, was deep and thoughtful and always available. In her mid-twenties, she was just a kid herself, more like a big sister.

All the nuns at Saint Mary's wore a huge white "halo" on their heads, making it tough for them to play sports with us because of the wind resistance and the visual obstruction. That didn't stop Sister Charlotte Marie from having fun. Tall and lanky, in wintertime she would gather up her ankle-length long black habit and jump on the back of my sled to zip down the hill with me.

Sister Charlotte Marie, who taught advanced biology at Saint Mary's, said and did the things that families ordinarily do for you. She'd tell you how much potential you had and urge you to study hard. She spoke about God with you and wanted to know how you felt and thought about Him.

I told Sister Charlotte Marie that I had stopped believing in God. Her response was to ask me to pray every night, "Lord I want to believe, help my unbelief."

I prayed that prayer every night and that semester those were always the last words rolling off my lips before falling asleep.

While the nuns called my room the "Dove Cot," everyone else at Saint Mary's called my room "The Pit" because I now lived with the nuns. Whenever something fun was going on in the dorm rooms at the other end of the Old Mansion, someone had to come get me.

While the mission of Saint Mary's wasn't limited to college preparation, the school's programs set out to mold the whole person. This included regular cultural opportunities.

My mission was to take advantage of being far away from home and the watchful eyes of my parents.

On one cultural outing the nuns loaded us into vehicles and headed to Chicago ninety miles to the west. They wanted to expose us to the legendary singing of Carol Channing, who became famous for belting out, "I feel the rooms swaying, for the band's playing," in her famous performance of "Hello Dolly."

Channing lifted the crowd right out of their seats with an electric performance that two years earlier had earned the forty-five-year-old a Tony Award for Best Actress in a Musical. While New York theatregoers were getting scalped for $500 a ticket, somehow the nuns scored tickets for us.

Other outings weren't so much fun, like attending the local opera house on a regular basis.

Perhaps I got transferred to the nuns' wing because I'd been seen sneaking out of the opera house during intermission, wearing the required high heels and formal dress, to get a hamburger and a soda at the little café down the street, only to slip back into my seat during the standing ovation.

Or perhaps it was because I had filled my empty Prell shampoo bottles with Tia Maria over the Thanksgiving holiday. Only I didn't get all the soap out of the bottles and we were sickened by the bubbly taste as we sat up in some big tree branches drinking, out of the sight of the nuns. Or maybe someone knew I was the one who loved to short sheet the seniors' beds, filling their sheets with Corn Flakes while they were out on their dates. That's why I got transferred to the "The Pit."

On the other hand, the transfer could have been the result of having helped produce an impromptu fashion show in one of the bedroom suites one afternoon. The show featured students wearing the sisters' habits we borrowed from the nuns' laundry room in the basement below us.

Maybe Sister Mary of Good Council found out about the ensuing pillow fight that ended the show. The girl dressed in Sister Miriam Edward's habit jumped up and down on the bed as she knocked the girl wearing Sister Yvonne Marie's habit over the head with her pillow. The repeated blows to the head ruptured the pillow, strewing feathers everywhere, causing onlookers to squeal in delight. Whatever the case, until boarding school, I had no idea Catholics had so much fun.

My eyes tried to see down the Mansion's unlit hall. But all I saw

were rows of doors leading to the nuns' bedrooms and the form of Sandy Barham's flowery flannel night gown up ahead.

While nuns lay sleeping only inches away on the other side of those walls, Sandy and I strained to listen for the sound of a toss or a turn in a bed, a nun's foot hitting the floor, a hand grabbing for a habit or the flip of a light switch. "Did the loud crack wake one of the nuns?" we silently wondered.

How had I gotten myself into this state? I found myself living two thousand miles from home because, when I was fourteen, my father suddenly decided to attend church and practice the Catholic faith my Grandma Bissell made sure we children were baptized in as infants, the Catholic faith we had never practiced as a family, the faith my Mother had never joined, but was now joining.

There had been a serious rift in our family and for seven years or so we barely spoke to my father's side of the family. They lived in New York and we now lived in California. And now we were trying our best to re-establish family relationships and return to the faith my Grandma wanted us to practice.

The result of my father's return to the church meant fulfilling the obligation of regularly attending Sunday Mass. Additionally, my parents announced that my two sisters, Jinx and Virginia, and I would be enrolled in Catholic schools. This wasn't just a simple return to the church; this was an all-out holy war! There was no stopping it. I was given the choice of either riding the bus to Saint Monica's High School in Santa Monica or flying off to Saint Mary's Academy in South Bend. I chose to fly off to the Indiana boarding school.

My one-year-old brother, "Little Karl," was too young for religious instruction, he would be spared, but he would be dragged to church with us on Sundays.

We all wailed and moaned at the loss of our typical Sundays spent at the beach in Malibu—a short walking distance from home. Now when Sundays rolled around, we would lie in bed longer than usual, making

Dad scream and yell across the house to get us up for church. There was no point in getting up early because, as we quickly discovered, practicing Catholics fasted an hour before going to communion. You couldn't even make yourself a slice of dry toast until after Mass, unless you were feeling sick; then you were exempt from the rules of fasting. These excuses had to be rationed judiciously.

After quite a ritual of delays and yelling, Mom and Dad managed to stuff us all into the car. For ten minutes we flew past Malibu's beach scene on our right. We watched wave upon wave crash onto the shore— carrying an occasional surfer, while we headed south on the Pacific Coast Highway to Our Lady of Malibu Catholic Church.

On the way to church, mom would realize we forgot our chapel veils. Chapel veils were cloth head coverings typically triangular or semi-circular in shape and usually made from white or black lace. In those days, no respectful Catholic woman would be caught in church without one on her head. The veils were symbols of humility, submission and reverence.

Dad would curse as he made his detour to the grocery store. That's where he idled the car out front as one of us dashed in to buy the only suitable substitutions for chapel veils--white paper dinner napkins.

Mass had already started when we got there. We took our usual spot in the back where late people sat. And so there we sat, the lot of us. We were hungry, late, and all dressed-and-bound like stuffed turkeys with dinner napkins on our heads.

We listened to Father James O'Callahan's Latin service, while Mom and Dad took turns pacing in the back, bouncing Little Karl on a hip in order to keep him from screaming.

Through most of the service I took to thinking and daydreaming to cope with it all. First I'd look around to see if anybody else my age wore a dinner napkin on their head. Of course they didn't. We were the only ones. I was mortified. At least we weren't sitting in the front pews. I could be thankful for this. I didn't understand yet that I came from a family of creative people. These odd solutions to problems helped me make my decision to go away to boarding school instead of going to the local Catholic schools my two sisters now attended.

By the time Father O'Callahan got into his sermon, I'd already slipped out the building in my mind. Using the coping mechanisms I developed from the painful family rift years earlier, I daydreamed about past adventures. I recalled riding bareback on my horse *Pork Chops*, my fingers clutching his sparse brown mane while we thundered down a stretch of Malibu's beach.

Next, I recalled riding into a few feet of surf to see how he would take to it. He liked it. He liked it so much he took control of his bridle and headed straight out to sea, oblivious of my efforts to rein him back around to the shore.

It all happened so fast. The waters quickly engulfed us. With no saddle to cling to, my legs became like two dead logs drifting uselessly behind me. In order to keep my body from floating off, I dropped my face down onto Pork Chops' neck, wrapping both arms around him. I held on tight while his body convulsed and his feet pumped in rhythmic furor like four pistons trying to keep a steam engine going. All that remained above the surface was Pork Chops' head and neck. Yet somehow he kept us afloat. I wondered what would become of me if I were to fall off and get caught up under his hooves.

In my panic to hang on, I had let go of his reins.

Fear gripped me.

Helplessly I watched the long leather straps floating along either side of me. I had made a grave mistake riding Pork Chops into the sea.

I'd been on a runaway horse once before. I was riding bareback on a beautiful brown gelding named Herbert. The day was hot and lazy as I rode through a cow pasture headed for home. I had let my guard down and along with it the reins, which lay loosely draped over *Hebert's* withers when something spooked him. Herbert took off running heading full speed toward a four-foot high barbed-wire fence. Mom and Dad had told me over and over about how you stop a run-a-way. Usually a spooked horse will clamp its teeth down on the bridle's bit, they had told me. When a horse does this, the chinstrap of the bridle no longer works to stop or turn him. You can pull up or try to rein the horse in, but only in vain.

They told me a horse will always travel in the direction its nose is

pointed in. And a horse has to slow down to almost a stop in order to make a sharp turn.

Using these emergency procedures they had drilled into my head, I pulled up the slack on Herbert's right reign. When I got the rein tight, I pulled his nose towards my right knee. It worked. Herbert began to slow down and turn, and eventually he had to stop.

Pork Chops' breathing now became labored as he took us further and further out to sea. His churning slowed while his nostrils snorted and flared. He struggled to keep his nose above the water. Pork Chops neared exhaustion. He was going to drown. I had to figure out how to turn him. With my legs still floating uselessly behind me, somehow I was going to have to hang on with one hand, while I retrieved a floating rein with my other in order to pull his nose around towards my knee.

But the waves were punishing me for my youthful foolishness. They slapped me in the face and stung my eyes with a continuous supply of salt water. I squinted through blurry eyes looking for a rein.

While moving further up Pork Chops' neck, I got closer to a rein that seemed to float out of Pork Chops mouth. Reaching down, I caught the rein on his right side. Inching my fingers up the leather, I took up the slack while hanging on with the other arm. Now I had to pull without submerging Pork Chops' nose.

I pulled.

I pulled and Pork Chops began to turn.

I pulled more.

He turned more.

We were now swimming almost parallel to the shore. The waves kept rolling over us, only now they began smacking us broadside, making Pork Chops teeter in the surf and making my legs drift towards the shore. My legs were causing us to be off balance. It was too much. I couldn't hang on any longer and I lost my grip on the rein.

Suddenly Pork Chops felt different beneath me.

His legs thrashed through the water faster now like the churning of one of those old-fashioned hand-crank eggbeaters. He continued to turn! Only he now turned on his own volition.

He seemed to see the shoreline! He aimed us right at it. The closer

he got us to shore, the faster he churned. He swam like an athlete coming in for a strong finish.

We finally hit solid ground and Pork Chops climbed out of the sea. I fell down on his neck exhausted and filled with relief and thankfulness and then I slipped off of his magnificent body.

I walked Pork Chops all the way home following the little dirt trails that led from Point Dume's beach to our house on Birdview Avenue. Hosing Pork Chops down, I got the salt out of his thick brown coat. Then I bedded him for the night with a bucket of oats coated in molasses and threw him some alfalfa hay. That night at the dinner table I sat in silence not telling anyone what had happened.

Mass was over and the daydreaming ended and I found myself riding in the back seat of our car headed back up the Pacific Coast Highway.

Finally, Sandy Barham and I made it past the part of the hallway where most of the nuns lived. The building took a hard right angle to the left. One more room to pass and we would be out of danger of waking up any nuns. As we traveled past Sister Charlotte Marie's room, the floorboards held firm allowing us to move more quickly. We traveled down the long hall way past the showers, past the bath area; we climbed a few stairs, took another turn to the left, and entered the wing where most of my out-of-state classmates lived.

As Sandy and I entered the last stretch of hallways, we could see Suite 2 straight ahead. The four girls who roomed in Suite 2 were hosting a pajama party that by now was in full swing. They had dragged in the TV from down the hall. They had snuck down to the nun's kitchen where they stole the sweet rolls intended for tomorrow's breakfast, along with a big industrial-sized box of potato chips. That wasn't all, they found the wine closet and swiped a bottle of that too.

My heart was still thumping from the long trip down the halls when I got the idea with Janet Sorg, a boarder from Defiance, Ohio,

that it would be fun to scare everybody and make them think a nun was coming down the hallway to catch us.

Janet went and got her rosary and headed down to the far end of the hall. When she got to the end she turned around and headed toward Suite 2 making big loud booming steps and swinging her beads like she was Sister Miriam Edward. I stuck my head into Suite 2 and hollered, "The Nuns!"

It worked. Girls were bumping into each other fighting for places to hide. There were only four beds, a bathroom and a big walk-in closest to hide about fifteen-to-twenty girls.

My body collapsed in laughter, and everybody stopped scrambling, realizing it was a joke.

Suddenly, I heard a noise behind me. Looking down the hall, I saw that Janet Sorg had a terrible look on her face. And she was looking in the direction of the convent wing where I had just made my long journey to the party. When the boarders saw the expression on my face, they took up where they left off searching for hiding places.

I ran into the big walk-in closet and yanked open two wood doors deep within the first closet. Behind those doors were coats and dresses all neatly in place on their hangers. I parted the clothes, slipped into the space next to them and closed the doors. Another boarder got the same idea. I could hear her breathing next to me.

When the door swung open to Suite 2, it wasn't Sister Miriam Edward, but Sister Yvonne Marie.

Sister Yvonne Marie, a religion teacher who was young, quiet and rather serious. We all called her "Minnie Mouse" because her slender frame seemed so delicate and she had a long straight nose that seemed to meet her chin. It was hard to read Sister Yvonne Marie. She was gentle and kind and a woman of very few words. Not knowing what she was thinking gave her an air of mystery and power.

There were too many girls to take cover in Suite 2 that night. Each of the four beds held at least one girl on top, and had two girls underneath.

One girl lay still in the old claw bathtub staring up at the ceiling when Sister Yvonne Marie came into her view.

She looked the girl in the eyeballs and wheeled around heading for the walk-in closet. We could hear the main door of the closet open. Next, came the flip of a switch and the illumination that followed. I felt safe embedded between the dresses and big winter coats behind the second set of doors, until I looked down at my feet. In my rush to hide, I didn't realize that when I closed the inner closet, my toes were sticking out the two doors.

Sister Yvonne Marie walked over to those toes, yanked the doors open, and there I was, staring nose-to-nose into the eyes of "Minnie Mouse."

From the time she first spotted Janet Sorg in the hallway, until she left Suite 2, Minnie Mouse never uttered one word. She toured the room. She walked past the sweet rolls. She walked past the big industrial-size box of potato chips. She saw the wine and noted that the TV had been dragged in from the hallway. Taking mental note of the party's attendees, she paused long enough to look each girl square in the eyes. All the while she remained silent—keeping her hands clasped together under her long black habit like she were a cloistered nun strolling about the grounds on a silent retreat or something.

Leaving Suite 2, Minnie Mouse finally headed back down the long dark sets of hallways to her room in the convent wing.

The next morning the nuns summoned the entire sophomore class of boarders to hear about punishment options.

The nuns told us we could either go to early morning study hall for a period of time as our punishment, or attend early morning daily mass with them—something the boarders did sparingly.

By the end of the semester I noticed I was changing. I began to settle down and to connect and to participate. I even took to studying my books more. Sister Yvonne Marie gave me private religious instructions and had me reading from the Bible on a regular schedule. It seemed so foreign, all the strange names and unfamiliar stories. It happened slowly. One day I sat alone reading my chapter of stories when I just realized that I believed in a God. When Sister Yvonne Marie came back to check on me, I didn't tell her about my newfound belief. I just sat with it quietly. I not only believed in God, I wanted to be a nun. But,

I didn't know how that was done. The other students said you had to have a calling. What was a calling? I wanted to ask, but I was too shy and thought surely I would not be taken seriously.

The nuns that ran the school had other plans for me. They decided I should not return to Saint Mary's for my junior year because of a smoking incident in one of the dormitory bathrooms. Toward the end of the semester, some boarders had decided they were going to smoke cigarettes in my bathroom. I joined them. I had never lit up a cigarette before, so I lit a cigarette and blew out—not daring to inhale. Somehow the nuns found out about the smoking incident. Sister Charlotte Marie pleaded with the administration for me to be able to return, but to no avail. However, she did make me promise right there in front of her, as I stood outside saying good bye for good, before I left for the airport, that I would study hard and that I would not get into drugs and other destructive things that were so prevalent in California in the 60's.

She wrote me letters, lots of letters, all through the rest of my high school days, and even today I hear from her. Sometimes the letters were four-pages long. Sometimes they were just little post cards. Three times in the letters she reminded me, "Remember, you promised."

By now alcohol began to take its toll at home and our little family found itself in turmoil once again only this time from within. My parents' marriage teetered and their fragile faith got challenged when the priest who brought them back to church was replaced. After his replacement, going to Mass for them only occurred during Easter and Christmas. On Sundays I would borrow the car and go to Mass by myself. After about a year of that I decided it was about time I went to communion. So one Sunday, I just got up and went.

Sister Charlotte Marie's letters kept coming to the mail box, parenting me, making me believe in myself, giving me calm, giving me stability and giving me hope by reinforcing the belief that we had a calling in life that we had to discover.

Meanwhile, I did remember my promises to Sister Charlotte Marie. In fact, the belief in something greater than myself kept me from many things that could have destroyed me, or altered my course. It was the 60's and hard drugs were rampant. If drugs didn't take you down, some

young people went up to San Francisco and ended up on the streets or in a commune.

In one letter she told me, "I'll always have faith in you, until you prove to me that you don't care anymore, and I hope that time never comes. Seems there are many other ways to let loose besides getting drunk or high on grass, or going to bed with somebody, but then maybe I see a different value in life. I think you do too. Seems like when people can find life worthwhile and get involved in things which are meaningful, then there isn't such a need to escape."

"Life's problems are solved by facing them," she told me in another letter, "not by running away."

"Do I sound Goofy?" she wrote.

She didn't sound "goofy" to me. I always believed she saved my life. Because of her letters, I passed through the 60's not only intact, but also finding my faith and deeply caring about others. Most of all, because of Sister Charlotte Marie, I accepted her belief that people had a calling in life and that I had to find mine. But finding my calling in a household like mine seemed as difficult to me as trying to catch a few wisps of wind and stuff them into a box.

## CHAPTER TWO

# THE BEER BARON AND THE NAUGHTY LITTLE MOUSE

**B**Y THE TIME I ARRIVED at boarding school, and after having been wrenched from the family social order eight years earlier, no one would have recognized that I came from the close-knit family of Peter Doelger—a prominent New York beer baron who emigrated from Germany and made a fortune in beer. I was unstructured and not trained in the ways of the wealthy family I descended from. The rift had altered our family's course forever. Nor did my demeanor suggest I was named after a Catholic nun, a Maryknoll nun no less.

Marie Madeline Doelger, my great aunt and my namesake, was Peter Doelger's middle granddaughter, and Peter's oldest granddaughter, Phoebe Doelger Bissell, was my Grandma.

In 1912 Mary Joseph Rogers began directing a small band of women who at first referred to themselves as "secretaries." They called themselves secretaries because they were assisting Father James Walsh with his work of mission education. Father Walsh had started a monthly publication, *The Field Afar*, about the foreign missions, and needed help with editing, writing, translating and archiving the growing photo collection.

Twenty-six-year-old Marie Madeline Doelger became the

twenty-first person to join the efforts eventually taking on the name Sister Mary Magdalen.

Eight years would go by when, in 1920, the original founding group of seven women had grown to forty women. That's when this founding group became formally recognized locally as a Diocesan Religious Congregation. The group took on the name The Foreign Mission Sisters of Saint Dominic, commonly known as the Maryknoll Sisters.

In short order, the little band of secretaries were able to turn themselves into an overseas mission congregation for women—the first of its kind. Maryknoll Sisters made history again by becoming the very first American congregation to actually send sisters to the foreign missions when they sent a group of sisters to China. Today, Maryknoll sends sisters to 24 countries.

Sister Mary Magdalen, my great aunt, headed the order's first American mission when she was put in charge of the Japanese mission in Los Angeles in 1920. Two years later, in 1922, the order reassigned her to head a permanent mission in the interior of China in Yeungkong, where two of the founding sisters were working part-time with Maryknoll Father Francis Ford (later to become Bishop Ford), who had arrived there in 1918.

Sister Mary Magdalen served in China for only three years when her order called her back to Maryknoll in Ossining, New York, to serve as a Novice Mistress. Then, in 1932, her dream came true of one day being able to devote her life to prayer and sacrifice when she and nine other sisters became the pioneers of a new cloistered community within Maryknoll. Sister Mary Magdalen served as the cloister's first Superior.

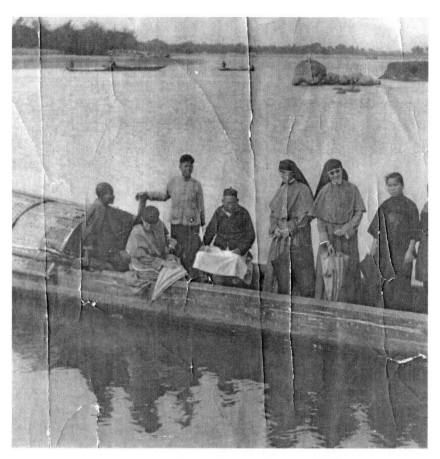

*Maryknoll Sisters Rose Leifels and Mary Magdalen on a
boat with the Chinese in Luoding, China, 1925.*

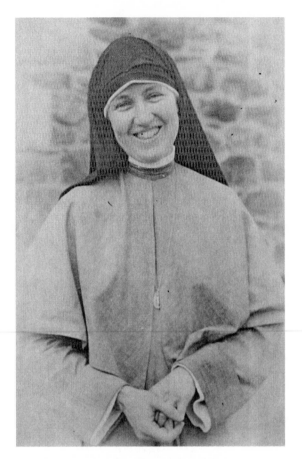

*Sister Mary Magdalen, MM.*

She lived out the remainder of her life as a cloistered or contemplative nun. Her sister Charlotte became a portress for the Cloistered Community in the early years, and family members visited my great aunt at the Maryknoll Cloister where she remained in constant contact with some of them.

Bishop Francis Ford,who began the China mission with those first few groups of sisters, continued to work in China for 25 years until he was jailed, tortured and killed by the Chinese. Of the 34 Americans who remained in a Chinese prison in 1952, the year Ford was killed, 25 of them were missionaries.

While my great aunt lived one kind of life, her sister, my Grandma, lived another. Grandma lived for the love of her large family.

German breweries were most often family-run operations. Usually the eldest son managed the company while the other children ran related operations. These Bavarian beer barons typically belonged to the same social clubs and vacationed together in Long Branch on the Jersey Shore.

The children of beer barons were encouraged to marry into the families of other beer barons. When my grandmother married my grandfather, their marriage was typical of one Bavarian beer baron's granddaughter marrying another beer baron's grandson. My grandfather—Karl Hauck Bissell, was the son of Doctor Joseph B. Bissell, a surgeon and the grandson of Peter Hauck of the Peter Hauck and Company Brewery.

Brewing families often lived in large mansions in close proximity to the brewery. Grandma and Grandpa lived at Hilltop Manor, a Mediterranean Revival style country mansion that overlooked the Connecticut River in Suffield, Connecticut. Industrialist George Hendee built the mansion. Hendee was the first to mass-produce the Motorcycle, followed by Harley Davidson a year later. Hendee founded what eventually became the Indian Motocycle Company in Springfield, Massachusetts.

The original 500 acres of Hilltop Farm was developed in 1913 to serve as Hendee's gentleman's estate. Grandma and Grandpa Bissell purchased fifty-six acres from the original 500-acre estate, which included Hendee's mansion and numerous quarters for the workers.

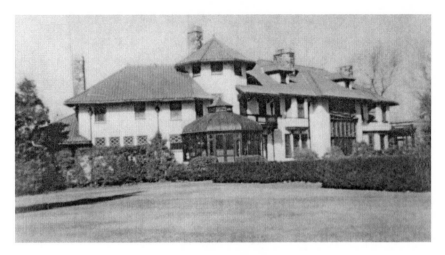

*Hilltop Farm Manor, Suffield, Connecticut.*

In the early years, our family was an integral part of the close-knit Bissell clan, sharing Christmas, Easter, the 4th of July and Thanksgiving together with the many aunts, uncles and cousins of the Bissell clan. When my father was named President of Hampden-Harvard Brewing Company, the family brewery, we lived at Hilltop Farm with Grandma and Grandpa Bissell in a three-bedroom apartment over an eight-car garage and bowling alley that had at one time served as Hendee's chauffeur's house.

On weekends, my older sister Jinx and I would wait for Grandpa to pull on his leather gloves so we could follow him around while he trimmed the hedges and pruned the trees. Even though there were more trees than he could ever prune, each tree he stopped at got his full attention and care.

Whenever he made a big cut to a limb, he'd seal the wound with a small brush gooped up with some sticky coal tar he carried with him in a little tin. One time Grandpa's trees got an infestation of aphids. Rather than use pesticides, he shipped in thousands of hibernating ladybugs to take care of the problem. Grandpa stored the hibernating bugs in one of Grandma's refrigerators until it was time to release them. When the temperature got right, he walked about the grounds sprinkling the bugs

everywhere, while my older sister Jinx followed behind trying her best not to step where he sprinkled.

We could wander about anywhere we wanted to on the farm—even though we were barely grade-school age, but Grandpa forbid us to go down to the Connecticut River, for fear we would get into some danger or scare away the nesting bald eagles.

When I was only about five or six years old, Grandpa seemed worried I might one day run into a wild animal in the woods, where I loved to play. So he instructed me on what to do if I were to ever encounter one. First, he told me that should I see such an animal, I should freeze right there in my tracks. Then, I was to look the animal in the eyes, all the while not moving a muscle. Lastly, he told me to bare my teeth, like I was an angry dog.

It wasn't long after Grandpa's lecture that his advice came in handy. Early one morning I ran naked down the apartment steps to bring in the newspaper. When I stepped outside, the door slammed behind me locking me out. No amount of pounding got anybody's attention upstairs. So I headed for Grandma and Grandpa's house. Since I was naked, I decided to go through the woods near the river instead of walking across the big open lawns. I was half way to my grandparents' house when suddenly something streaked in front of me. I froze. It froze, too. There stood a wild animal—about the size of a bobcat—right in front of me staring me down. We stared at each other for a long time, and then I remembered that in addition to staring I needed to bare my teeth. I raised my lips showing him my teeth like an angry dog—all the while being careful to not move any other part of my body. As soon he saw my teeth, he took off running, disappearing into the woods.

When I got to Grandma's house she wrapped me tight like a papoose in one of her big white fluffy bath towels embroidered with her initials. She told me I looked like I had just seen a ghost. I never told her what I saw. But after that experience, I practiced walking through the woods, suddenly freezing, fixing my eyes and then baring my teeth. Thankfully, I never had to use those skills again.

The mansion, with its 17 rooms, was our playground for hours on end. In the fall, when the leaves started dropping, Bill, one of the

groundskeepers at Hilltop, raked them up into huge mountains on the back lawn. We would run and dive into the piles, scrambling to be the first to reach the top to be named the King of the Mountain. We sprang up and down on the piles like we were on trampolines.

Inside the mansion, Grandma would have to dust us off so we wouldn't track dirt over her fine wool carpets. We'd play in the steamer trunks stored in the attic. We'd dip our fingers in the holy water fonts Grandma hung near the light switches on the walls of every bedroom. Grandma would bring us plastic glow-in-the-dark rosaries. We'd run outside to charge them up, and then head for the coat closet to watch them glow. We'd also play with the staff. Dick, the chauffeur and house keeper, was our favorite. He would give us ideas of where to hide when we played hide-n-seek with our cousins.

In the basement of the old mansion there was a fully stocked saloon with an array of tables and chairs—like the kind you would sit on while you drank whiskey and played poker. Off to one end of the room was a long wooden bar with tall stools to sit on—just like in the Westerns. We would climb up on the stools—sometimes dressed in the lederhosen Uncle Willie brought back from Germany, and Grandpa would be waiting behind the bar to serve us. He would pour some dark liquid in a shot glass he set down on the bar for himself. Then he would set an empty shot glass down in front of each one of us, pouring our glasses full of the same dark liquid. He'd propose a toast and proceed to slug it all down in one gulp. We lifted our glasses and followed suit.

After we downed our shots, he would reach up on the shelf behind him where he stored some savings cards he got from the bank. He had written our names on the cards and he would slip a dime in a slot on the card for each time we took a shot of the liquid vitamins he had just given us, or swallowed one of the little orange pea-like vitamin pills he kept in a jar. While he had us perched on the stools, our empty glasses all in a row, he'd set out to lecture us even though we were almost too small to even climb up onto the stools. He'd lecture mostly about the importance of having an education…a "trade" he called it. Sometimes he would talk about nature and his trees and taking care of the environment, so the

next generation would have something beautiful. He spoke a lot about the next generation and how you have to leave something for them.

If we were lucky, Grandpa would tell us about the fight he had in the Wild, Wild West, when he had to use a broken beer bottle to defend himself. He claimed that when he watched Westerns, he kept two pearl-handled, hair trigger 45s near a table on either side of him in case somebody broke in while he watched TV. Before he could tell more, if Grandma happened to enter the room and hear the stories, she would put her hand over his and pat him a few times saying, "Now Karlie dear." He would take the cue to change the subject.

Grandma Bissell attended daily Mass, dragging Grandpa with her on Sundays. Grandpa Karl couldn't endure long sermons. Before Mass he would tell the priest how much he intended to donate during the collection. He then told the priest that for every minute he went overtime on his sermon, he would begin deducting dollars from his offering.

Grandma had gone to Europe's finest finishing schools, and she wanted us to be proper. She would give us instructions on how to behave. Grandpa, on the other hand, called us "naughty little mice," and delighted in our untamed natures.

Friday was the day Catholics had to eat fish, but it was also our big day when Grandma pulled together her large family around the dining room table. The Bissell clan would gather at Hilltop Farm to eat, and to laugh and play. My aunts and uncles would sit around and talk about beer and politics, and tell stories and solve the world's problems. When dinner was ready, Grandma would choose one of the children to hit the big gong, calling everyone from the mansion's Great Hall to come to the table. Grandma loved place settings. She collected serving plates from all over, and she would have Tashiro, her Japanese butler, set down a different piece of china next to each sterling silver setting. The first grandchildren to arrive in the dining room would fight over where to sit. If Grandma wasn't looking, fights were settled by licking the plate you wanted to eat off of as a way to lay claim to it.

While our family often looked like "unruly sled dogs," according to Aunt Olivia, it was Grandma who held things together. She was the

one to make sure we all bowed our heads to give thanks, as her German cook Gertie remained in the kitchen cooking and making sure the table stayed heaped with big bowls of steaming clams and lobster and corn on the cob. Each member of the family would have their own small bowl of melted butter to drag the lobster and clams through. Somewhere on the table you might see a big platter that held a whole fish, whose pleading eyeballs gazed into yours all during the meal. If a dish needed carving, Grandma did the carving, handing each person's plate to the person seated next to her to be passed down the line.

Grandma had crystal finger bowls set out at each person's seat so we could clean our hands before the meal. First you dipped one set of fingers, then you dipped the other, then you dried.

When Dad first brought Mom home to meet the family; they were invited to eat at the family table. When Grandma jingled the little crystal bell at the head of the table, signaling it was time for the family to begin the meal, Mom started her meal by drinking the water in her finger bowl, thinking it must be some exotic appetizer or soup prepared by Tashiro. As she brought her spoon to her lips, the family politely looked on. Even though Mom wasn't properly trained, that didn't stop Grandma from loving her. Mom was kind, quick to laugh, and up for almost any adventure.

Eventually we moved to a country home in nearby Granby, Connecticut. Dad had learned about a man who got into some trouble and needed someone to take a risk on him by employing him. Dad hired him straight out of jail. While Bill worked on the grounds and tended to the horses, his wife Thelma worked full time as our cook and housekeeper. The next thing you know Bill and Thelma moved in with us, living in some living quarters Dad built as an addition to the house. While Bill and Thelma stayed below, the three of us girls lived in a dormitory-style room upstairs. We weren't allowed to have the cat in the house, so one day when Mom and Dad were occupied hosting a party, I went outside and tied a belt around the cat's waist, attaching a sheet Jinx and Virginia lowered to me as they hung out of the second story window above. When they began to hoist the cat up to the second floor, about mid-way, someone opened the curtains to the big picture window

and there was the terrified cat floating in air dangling by a sheet for Mom and Dad and all the guests to see. We never got punished. Like my Grandpa, Mom and Dad loved the antics.

In the evenings we sometimes gathered in the living room around Mom's baby grand piano Dad bought her. That's where Mom's body would swoon as her sweet-sounding soprano voice enraptured us with the romantic lyrics of Blue Moon:

> *Blue Moon*
> *You saw me standing alone*
> *Without a dream in my heart*
> *Without a love of my own*
> *Blue Moon*
>
> *You knew just what I was there for*
> *You heard me saying a prayer for*
> *Someone I could really care for*[2]

While Mom played, Jinx would lie on her back nestled in the carpet underneath the big black piano, while Virginia sat on the bench next to her listening to her play and sometimes picking out notes.

But it wasn't all love songs from the 30s, 40s and 50s, that Mom played. She loved the jump blues and swing styles that came out of the big band era from composers such as Lionel Hampton and Benny Goodman.

Mom's fingers hammered and pumped, rhythmically pounding out the musical phrases of the one, the four, and the five chords to the Boogie Woogie Blues.

We had become a contented, wealthy family.

*Left to right: Karl H. Bissell, Jr., Virginia, "Jinx", Marie and Jeane Bissell.*

Then it happened. I was just finishing up fourth grade when the wheels came off and our family fell apart.

My dad was fired from being president of the family brewery.

You could politely call it a power struggle with a family member. At least that's how it looked. Or you could say that Dad drank too much… another explanation. But Dad said it went deeper than that. While two of his brothers were already gone from the family business, this family member served on the board that fired him. After the firing, the family member took over as President.

Few people wanted to believe my father's insistence that there was a motivation for the firing.

Dad insisted this person was a "crook."

Dad's accusations were so serious they were unbelievable. The rest of the family couldn't believe him, they didn't have the capacity to believe him, and it was unthinkable to believe him.

Given the two choices, it was less disruptive to believe Dad had

a problem that deserved a firing, than to believe this person had a problem.

According to Dad, when the lawyer looked at the papers Dad presented to him as evidence of this person's misdeeds, the lawyer told Dad the consequences of pursuing his case would land his own family member in jail.

Oddly enough, Dad never had to make such a tough decision. The office of the lawyer he retained burned to the ground, taking all Dad's paperwork with it. Though eyebrows were raised, the matter ended, and that's where we parted ways with the family. That's when Dad chose to deal with it by removing himself completely from the situation. We moved away from the family to Nelson, New York and next moved out West.

Over six long years would pass before we started speaking to my grandparents again. And it would be another ten years before Grandpa apologized to Dad, telling him he was going to make sure he was paid back for what was taken from him. But within two weeks of those promises, Grandpa Bissell was dead. He died from being poisoned. That was in 1973.

All told, thirty-five years would pass before members of our family understood the true depth of that family member's problems. That's when, in 1992, a jury of his peers did what people in my family either didn't want to do, or were not in a position to do. The jury stopped him. They stopped him with a conviction that led to a 10-year prison sentence for racketeering. When the law caught up with him, and reporters began uncovering his escapades, our family discovered that we weren't by any means his only victims. It was then that Dad could finally stop saying, "They don't believe me," and his relationship with the last doubting member of his family began to heal.

But the damage was done. The family life, our home, the support of my grandparents, the laughter, playing with my cousins Peter and Joseph, Phoebe, Tiger, Mary and baby Olivia...relationships never made with many cousins yet to be born, listening to my aunts and uncles tell stories at the family dinner table, the holidays, friendships with the hired help, Tashiro, Gertie, Dick, Thelma and Bill...it was all gone.

While my father looked for a job after the firing, we rented a three bed-room dilapidated farmhouse on Irish Hill Road in Nelson, New York, 20 minutes from my Mother's family in Erieville. We were in dairy country, surrounded by milk cows, and the many acres of corn, wheat and alfalfa hay it took to see the animals through the harsh winters.

According to Mom's diary, she first met Dad when he landed his seaplane on Lake Tuscarora in Erieville. Mom's family lived overlooking the lake and her father, Lynn Beebe, worked as a Branch Manager for the Syracuse Branch of the Dairymen's League. When Mom saw the plane land on the lake, she rowed out in her rowboat to see who it could be. It was Dad. In her diary she wrote that out stepped a tall handsome man with blond hair and blue eyes.

Our transition wasn't smooth. To anybody watching us, we must have looked like the sinking of a great ship, when the bottom falls out and chaos ensues.

At first we didn't know how to cook or clean the house. We divvied up the chores taking turns ironing Dad's white work shirts after spraying them down with starch.

We had trouble transitioning and often couldn't pay our bills because of the huge loss we took over the quick sale of our home and the crushing debt that followed. We stopped answering the phone to avoid the calls from the collection agencies. That winter the utility company turned off our electricity several times leaving us with no heat.

When winter came on that first year back in the late 1950s, our family learned what it felt like to be cold. We were cold. We were very cold. And we were poor.

Dad had a degree in electrical engineering, and he figured a way to get the heat back on until he could pay the bill. The farmhouse wasn't insulated, and we hung a couple of blankets to separate the kitchen from the rest of the house to conserve heat and keep the bill down.

We weren't the only ones who were cold that first winter. So were the mice. The farmhouse was full of mice, field mice. When Mom realized she couldn't get rid of them, she painted the doorways of their little holes creating tiny neighborhoods with trees and flowers. She

named the holes "Mickey Mouse," and "Minnie Mouse," and "Mighty Mouse;" but it wasn't funny. Sometimes I went to school with holes in my shoes. Sometimes it was a long time before we had money for new ones.

In Miss Winan's class that year I just stared out the windows wondering what happened. How did I get so disconnected? I missed my Grandma and my Grandpa and my cousins and the staff, especially Dick the chauffeur. We didn't even get to say goodbye. We just picked up and moved.

Miss Winans tried to reach out to me. But there was nothing holding still long enough for me to grab. That year I flunked Miss Winans' class. I almost flunked my grade again the following year, but they passed me thinking holding me back twice in a row would do me permanent harm. Because I flunked, the kids teased me and told me I was dumb. I figured that it must be true. I must be dumb, or I wouldn't have flunked. I became ashamed of myself for being dumb and wouldn't tell my family that my classmates teased me. I lost all interest in school, developing a blank gaze when I entered a classroom.

My report cards reflected the trauma I felt inside of me. Cards came back with notes like, "Marie is always staring out the windows." I remember staring out that long bank of horizontal windows. I transported myself back to better times at Hilltop Farm, and how I wished things would be again. If I looked out that long row of schoolroom windows long enough my daydreaming could make everything better.

Those first few years were the hardest. My parents' friends watched them reel from the loss of both financial security and their cozy lifestyle. They advised them to file for bankruptcy. My father refused. He was too proud. He chose instead to hock everything of value to pay the bills, including the four-and-a-half carat diamond ring Dad gave Mom for their engagement—the ring my Grandmother's mother had worn. The decision not to file for bankruptcy added years to the time it would take my father to recover from his financial loss. For those first few years, our family moved frequently, sometimes twice a year. This constant moving severed what remained of any close relationships.

Finally, life got better. The year was 1964. Dad's engineering degree

earned him a good salary selling things like transformers to industries. We settled down in Malibu, California when out of nowhere, my brother, "Little Karl," was born.

Perhaps, naming my newborn brother after the grandfather we had become estranged from for so many years had something to do with the family's desire to reconcile. Naming my little brother after Grandpa symbolized a fragile gesture on Dad's part of wanting to get back with his parents. When Little Karl was born, this is what his short life did for the family.

Soon, after Karl's birth, Dad was speaking to his father again trying to get past what had been done. His parents flew in from New York to attend Little Karl's baptism. Everyone patched things up as best they could. Or so it seemed. In truth, things would never be the same. We didn't pick up where we left off.

In many ways Dad never recovered. For years he didn't allow himself to recreate a strong sense of community that went beyond the boundaries of his immediate family.

Even so, he was lovable and his lovable part lay tucked in his seemingly tough outer shell a family of mostly girls loved cracking. When we were younger and he threatened to spank us for misbehaving, all that my older sister Jinx had to do to save me and my younger sister, Virginia, was to stretch out both arms and wiggle all her fingers as she headed towards him saying, "I'm going to tickle you." He would pull his arms in tight while bending over in uncontrollable laughter, as if he was one of the girls. All the giggling took away his male authority, rendering him powerless, and threats of punishments from him were not to be taken seriously.

Years later when I took up scuba diving, he didn't like the fact that I had been trained in Louisiana in the buddy system where, if you get into trouble, you look to your buddy to save you. My training disturbed him and he insisted I dive alone at the bottom of Lake Powell to learn not to depend on anyone but myself. He wanted me to practice emergency maneuvers such as pretending I ran out of air and surfacing to the top. The waters were murky when he sent me spiraling down to the bottom of the lake. I wasn't happy about the creepy exercise he put me through,

but he insisted. So down I went. As I swam around down there suddenly I felt some kind of presence. I looked up and there was Dad...following my bubbles...ready to come to the rescue and give me his regulator, should I get into trouble at the bottom of the lake. I smiled knowing the exercise was more for him.

He not only was a softie, Mom described him years later saying he was a good man. She said that he helped his friends who needed jobs to find them. He was kind and spoke out when he saw an injustice. Whenever there was an argument with Mom or one of us, Dad never had trouble saying "I'm sorry." His apologies were so sincere, so pure-hearted and child-like, we had to forgive him immediately to restore the order of things. His cognitive abilities were well-developed and it was fun to ask him what he thought about things.

Now that the family was patching things, my Mom and Dad told us they wanted to return to the church to become "better persons."

My Grandma wanted us to go to Catholic schools.

It was my Grandma that made the arrangements and paid the tuition my sophomore year in order for me to attend the all-girls boarding school at Saint Mary's.

I was about 17 when a family friend reached out to my father and helped him seek help to quit drinking forever. Dad told people the reason he had the strength to quit drinking was for the sake of my now four-year old little brother who needed him.

About a year passed, I was 18 years old, when I got the phone call from Dad. "Marie," the voice on the other end of the phone said, "your little brother died today."

My five-year old brother was dead.

A vehicle accident took the life out of the little person who gave so much to all of us in such a short span. He was our very own Christ child. He came, he gave something to each one of us, and then he returned from where he came. Because he came into our world, in essence his birth healed the family rift, giving me back my Grandpa and Grandma who paid for my boarding school, which ultimately brought Sister Charlotte Marie into my life.

Even though Dad never drank again, and Mom stuck by him

through so much, after Little Karl died their marriage finally fell apart under the weight of it all. They did the worst thing you could do after losing a child. Instead of getting help and turning to a community of extended family members and loved ones, they isolated themselves. After the big family split, and all the moving around the country, they never made a real home for themselves. Their solution to the pain of losing Little Karl was to move again, only out of state where they knew absolutely nobody.

Dad's way to cope with the loss of his son was to throw himself into work. This left Mom home alone. A few years passed when she left him. They both remarried quickly.

A few years ago Mom and I rode in the car together on our way to Breaux Bridge, Louisiana, to go hear some fiddle playing. Dad had just a short time left to live and was living in California. Suddenly Mom turned to me and said, "Why don't you call your father." It was an odd request. They both were in their 80's now. I called him. When I got him on the line, Mom grabbed the phone from me. She started blurting out to him in a Katherine Hepburn crumbly kind of voice, "Karl. I...I...I love you. And I will always love you!"

Tears streamed down her cheeks as she sat crumpled in my passenger seat clutching my phone. I cried while I held her hand and tried not to drive us into the ditch.

All those years she had been unnecessarily hard on herself for leaving Dad. Those last words to him may have been the peace she craved. Meanwhile, Dad had found a life of happiness in Dorothy, his new wife, and in her family. Suddenly coming into a big happy family full of children and grandchildren seemed to heal him and bring him back to a place of contentment he deserved and had not seen in a long time.

I learned not to judge Mom's journey, or Dad's, for that matter. She needed to have what were to be her last words to him before they both were gone.

## CHAPTER THREE

# SOME NUN IN INDIA

I NEVER MET OR SPOKE TO my great aunt and namesake, Sister Mary Magdalen. My older sister Jinx got to see her once. Grandma took Jinx with her on the two-hour drive up to Maryknoll. Jinx would scamper about Maryknoll's huge lawns while Grandma visited her sister. I was too young to go. This was well before our family split off from my grandparents.

At boarding school some Maryknoll Sisters from the active branch of her order checked in on me, giving me her greetings. I was intrigued about the visit because it was at boarding school that I first thought I too wanted to be a nun. And now I knew this person I looked up to really existed and that she knew I existed.

While I was growing up, my father reminded me over and over, "You were named after a nun, you know." I loved being named after her. At a very early age the idea of what she stood for fascinated me.

But she was cloistered now. Cloistered nuns didn't venture out to teach or work in hospitals, or work with the poor in the world's slums in the way "active" sisters did. Though their religious formation was all the same when they entered, they usually stayed at the convent devoting themselves to a simple life-style, to poverty, to prayer and penance and to being a support to the sisters on the missions. Though they stayed back in the states, nonetheless, they kept up with the struggles of the contemporary world and that awareness helped to direct their life of

prayer and penance. In Sister Mary Magdalen's case, she had the same missionary heart fostered in every Maryknoller, but now her life of prayer would permeate her whole life.

Even though there is this contemplative branch of sisters within the Maryknoll order, Sister Theresa Baldini, MM, said that essentially every Maryknoll Sister is called to be a type of "contemplative in mission."

As a child, I visualized my great aunt sitting down praying all day, praying and being serious and being hidden away from the rest of us. I didn't learn until later, from my Aunt Olivia, that Sister Mary Magdalen was vibrant and jolly. In fact, I would learn later that the whole order of nuns was wonderfully adventuresome. It wasn't until boarding school that I had any hands-on experience with American nuns and what they were really like.

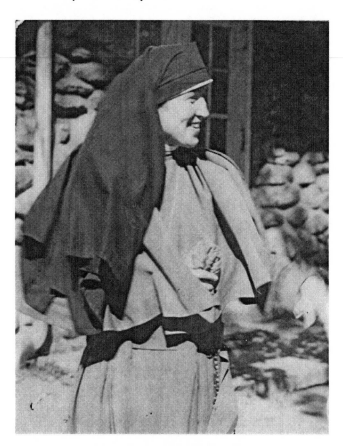

*Sister Mary Magdalen, MM.*

When I got older and was out on my own I could have gone to visit my aunt. But though time had marched on, separation from family members on my father's side lasted years, in part because most of them lived back East and we had moved out West.

When I was 25 and living in California in 1975, I really could imagine first-hand what Sister Mary Magdalen's life might have been like before being cloistered.

Thanksgiving fast approached and my neighbor and good friend, Cliff Witte, lit up when he spoke about some nun in India who worked with the poorest of the poor, picking dying people up off the streets and caring for them, and giving other people food and clothing.

Inspired by the then 66-year-old Mother Teresa of Calcutta, Cliff wanted our small circle of friends, about seven or eight total, to go to Tijuana over the holidays and bring the elderly people who lived there blankets so they wouldn't be cold in the approaching winter. Cliff wanted us to do the work of nuns!

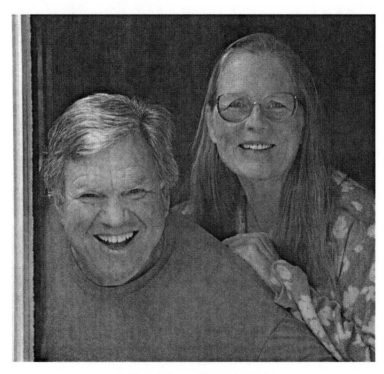

*Cliff and Teresa Witte in 2016.*

Cliff's handsome smile and good-natured prodding to get us to help the poor made it easy for me to say, "Yes."

As we set about telling our friends and neighbors about what we were up to, everybody wanted to pitch in to give something. Cliff got a commercial pilot to lend us his van and the pilot even threw in his gas card. Cliff also got Saint John Eudes Catholic Charismatic group to lend us their van. Over a two-week period so many donated items poured in that we filled an entire two-car garage of blankets, canned food, clothing and medicines.

The day before Thanksgiving we stuffed the vans and cars with supplies. None of us spoke Spanish. I claimed to know enough to get us by. I knew how to say, "Donde esta' el bano?" Where is the bathroom? And I could say, "Yo quiero una cerveza." I want a beer.

Not knowing the language didn't stop us though. We were young and fearless and innocent and filled with goodness and wonder. We had no idea what we were about to encounter.

Our caravan pulled into Tijuana armed with a few sentences of broken Spanish and a Mexican boy named Ricardo. Ricardo worked for my brother-in-law, Nikki, who owned a concrete pouring company. Ricardo had been telling us about his family back home in the village of Miramar, on the outskirts of Tijuana. Now here we were. After listening to all his stories of back home, it was Ricardo's village we were visiting.

We treated Ricardo like a family member. We'd sit around the dinner table and Ricardo would tell us stories about when he was back at his village, how he often ate beans for breakfast, beans for lunch, and beans for dinner. It was difficult for us to imagine…being so poor that you had to have beans for all three meals.

The village of Miramar had existed in a dry riverbed, but the politicians of Tijuana made the people move the village outside the city limits by the dump, because the poor were a deterrent to tourism and an embarrassment.

Once our caravan got past the guards at the border, we made our way through the city with Ricardo leading us. When we got to the other side of town, we found ourselves passing through the middle

of Tijuana's dump. Little children and mothers wandered through an ocean of garbage alongside pigs and dogs. The stench rose up like steam from a boiling pot as they looked for something to eat or something to sell. Everybody in our van became quiet.

Finally, we came to Miramar…a little pop-up village slapped on the side of a mountain. We saw row after row of houses made out of cardboard—like the cardboard you get when you buy a new refrigerator or stove. Not knowing the language, we couldn't talk to anyone, or ask questions, or tell them why we came, unless Ricardo was nearby to translate. All we could do was to hike up the hills, smile a lot, hug people and give out our goods.

The poor were not like the pictures you see where everybody is dirty and nobody is smiling. The little children giggled and wanted to be tickled and held. The adults were gracious and they looked at us with smiles and with love. For the most part, the insides of their tiny cardboard houses were tidy and clean. But a nearby mountain slope told another story of hunger and disease. There stuck in the ground were hundreds of little cheap white crosses where their loved ones were buried. It seemed there were more little white crosses on that mountain than there were shacks in the village.

When we handed out our gifts, they grabbed for the things they needed, and some of them also made sure the weakest among them, and the oldest, got the blankets and some food too. They tried to direct us to the ones who were sick and needed the medicines. We learned that "Yo tengo la grippa," meant somebody felt sick.

Each year Cliff went back to the little village a few more times on his own, bringing a priest, and they discovered that the people had flourished and didn't need more assistance. The cardboard houses had turned into better structures, permanent homes. Had it not been for Cliff's being inspired by Mother Teresa, we would never have made such a trip that forever changed most of us.

We agreed when we set out for Tijuana that after we passed out our supplies, we would stop in town to have fun and spend some money. Now here we were, on the way home, and nobody even mentioned

stopping in town. We sat in silence all the way home—unable to speak, processing what we saw.

For me, little did I know that in four years I would move to Louisiana, earn several degrees and make a living as a professional photographer. At the time, I didn't even own a camera, nor had I ever owned a camera. Yet because of my soon to be profession, I would come to know Cliff's Mother Teresa, I would laugh and joke with her, pass her in the convent halls and schlep gear up and down the East Coast as I traveled in her entourage photographing her while she participated in her sisters' vow ceremonies.

Little did I know that this trip to Tijuana would mark the first of many trips I would make to some of the world's worst and most dangerous slums, all because of my associations with nuns I hadn't met yet. I would never have guessed all this was in my future. There was nothing to remotely hint that this would be my journey.

## CHAPTER FOUR

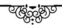

# HEADED FOR CALCUTTA

**A**BOUT EIGHT YEARS SLIPPED BY after my small group of friends experienced the unimaginable poverty of Tijuana. Now, in 1984, I was thirty-five years old and working as a free-lance photographer while I earned a second degree, this one from LSU's Manship School of Journalism.

Two years earlier Sister Mary Magdalen—my great aunt—had died at 92. I temporarily lost track of Sister Charlotte Marie; and I forgot about the work of nuns. I even forgot about wanting to be a nun. That is until Mother Teresa came to my town. Yes. Cliff Witte's Mother Teresa flew into New Orleans in 1984 and into Baton Rouge, Louisiana in 1985 and again in 1986.

My professor, Jay Perkins, asked me to go down to the Superdome in New Orleans to photograph her as she spoke to a large crowd of youth gathered there.

The following year, 1985, I photographed Mother Teresa for the second time when she flew in to Baton Rouge to set up a convent along with a facility for unwed mothers. Eventually a soup kitchen and homeless shelter for women were added.

I hung out in the yard with some detectives who acted as bodyguards for her along with other photographers from the local paper. We waited

outside the convent doors for hours, waiting to get our shots, hoping the famous nun would step out for a few moments.

One of the first things I noticed about Mother Teresa was that she walked around the convent in her bare feet. In fact, everybody in her entourage walked about barefooted. You'd knock on the door, and they'd come to the door barefooted. You would go into their convent chapel; they were all barefooted. I loved it. I used to walk around a lot in my bare feet.

As teenagers, we went barefooted in Malibu, rarely wearing shoes. We went into the grocery store barefooted, we went to the restaurants along the coast barefooted. I would have gone to church barefooted had my parent's allowed it. It was nostalgic seeing all these people going around barefooted.

Mahatma Gandhi used to go barefooted. So did Jawaharlal Nehru. In 1942, photographer Jayant Patel captured Nehru sitting and chatting with Madame Chiang Kai Shek. The great Indian leader Nehru was conducting business, in his bare feet.

Mother Teresa's first two visits to my city were wonderful moments for a professional freelance photographer. She was a famous 74-year-old nun, and I was a budding photographer. Her visits weren't personal to me like they somehow had been to Cliff eight years earlier. I didn't have any special moments with her, and I still knew very little about her. However, unbeknownst to me during those visits, I had taken what eighteen years later would become her official beatification photo, a photo the Vatican hung over the façade of Saint Peter's Basilica and unveiled in front of 300,000 people during Pope John Paul IIs 2003 twenty-fifth anniversary celebrations and her beatification.

There were other important photos too. But for the time being, all but a few of the photos remained unprinted while the negatives sat in legal-sized white envelopes I had stuffed into shoeboxes.

There they sat, for six years, tucked away on a shelf in my closet, until one evening I dragged myself in from an exhausting photo shoot, dropped down onto my living room floor, and flipped on the TV for mindless distraction.

Instead of distraction, the TV greeted me with images of Mother

Teresa of Calcutta who held a skeleton with skin, a barely-alive human who must have weighed only 70 pounds. Mother Teresa said in her subdued voice "God doesn't do this. We do it because we don't share what we have." The scene made me cry because I had just gone full-time from part-time in my commercial photography business. Being consumed by it all, I wasn't doing anything for anybody.

A few days passed. Mother Teresa's words haunted me, playing over and over in my head. Now six years after having met her and photographed her, those words drove me to introduce myself to her sisters, who, I remembered from the photo shoot years earlier, were running the Baton Rouge soup kitchen and shelter at Saint Agnes Catholic Church on East Boulevard. I drove over to Saint Agnes, knocked at the door of the side porch and said, "I'm here to volunteer. Do you need any help?" The nun in charge of the facility, Sister Maria Rose, looked me up and down while her eyebrows knitted out a suspicious look. After a long pause, she put me right to work washing dishes in the soup kitchen.

That was the summer of 1991. While I continued volunteering in the soup kitchen on Fridays, I got enlisted into helping in the women's homeless shelter when the sisters asked me to spend the night, and pull a few night duties each month. I was forty-two and the kind of work the sisters did made it easy for me to consider whether it was too late to become a nun.

The shelter had been an elementary school at one time, educating 245 children until the school closed its doors to relocate and merge with another school. When Mother Teresa's sisters came to town they had taken over the old vacant building, transforming most of the second-floor classrooms into dormitory-style bedrooms. They converted the first floor classrooms into a chapel, a kitchen, recreational rooms, offices and storage spaces. There was a small cot located in one of the offices on the first floor that at one time served as the Principal's office. That's where I slept.

Whenever the sisters admitted a new woman into the shelter she would invariably get the urge during the middle of the night to sneak down the stairs to do some exploring of her new surroundings below.

When she would reach the bottom of the stairs she would unknowingly break a beam that stretched across two walls, triggering the alarm. The alarm was the kind you'd install if you wanted to perform a full-scale military evacuation of a neighborhood.

The alarm not only woke the entire shelter, it blasted across the parking lot out front and into the convent located across the street. I would jump out of bed, throwing clothes on as fast as I could, all the while dreading having to step outside the safety of my room and into the black night in order to turn off the alarm mounted outside my door. To stop the alarm from screaming, I had to turn my back toward the darkness and it scared the wits out of me. To my great relief, I was never quick enough to catch the night explorer. When I got faster at it, sometimes I could turn off the alarm in time to hear footsteps running back up the stairs. The sound of the steps would end when the culprit dove under her sheets, pretending to be asleep.

During this time, I met Sister Sylvia, the order's Regional Superior who flew in from the Regional House in San Francisco to visit the Baton Rouge operation.

It didn't take Sister Sylvia long to discover my trove of negatives taken during Mother Teresa's first visits six years earlier. There we sat, on the back steps of the convent one lazy afternoon, going over page after page of contact sheets with a small magnifying glass I brought along.

Once she saw the contact sheets, she had me spending hours in the darkroom where I made prints by hand, the size of book markers, for her to give as gifts to the sisters taking their vows.

When Sister Sylvia invited me to fly to San Francisco to photograph an upcoming vows ceremony in which the sisters publically promise chastity, poverty, obedience and wholehearted free service to the poorest of the poor, I jumped at the opportunity.

During that visit, I met volunteers from California who told me stories of the work in Calcutta in the many facilities run by the sisters. At the urging of the sisters and Sister Sylvia, at Christmas time in 1992 I found myself headed for Calcutta, packing three cameras and more than sixty rolls of film. I wanted to work with the nuns and make some

images of the people on the streets. Sister Sylvia wanted me to bring back new pictures of Mother Teresa.

The week before my departure for India, the country had thrown itself into bloody civil unrest after a small group of radical Hindus demolished a sixteenth century Muslim mosque in Ayodhya. A political rally had turned into deadly rioting, eventually involving over 150,000 people. Many Muslims were killed that week and more would die during the nights ahead, eventually totaling 2,000 deaths. The Indian government imposed a strict curfew to prevent additional violence.

Sister Sylvia had arranged for me to have a traveling companion—a sister from the order who was returning to India. She also arranged for us to be picked up at the Calcutta airport by some sisters who worked nearby. After a two-day journey that included a stopover at a Singapore convent, our plane touched down in Calcutta at 11 p.m.

The nuns who met us at the airport had bypassed the curfew by arriving in an old ambulance they used for picking people up off the streets. The ambulance would allow us to pass through the streets unbothered.

Even though the curfew stood in full force, it didn't stop the local airport beggars from conducting business. Within seconds of stepping outside the customs area and into the night, they swarmed me, pushing my bags and me further and further from my companions and into an area that was dimly lit. One sister saw what was happening and called out scolding them. The beggars broke the circle as instantly as they formed it.

Over the years I would learn that being in the company of nuns wearing habits was probably as safe as riding in armored tank cars, during times of peace anyway. Not so with war.

In 1996, a few years later, I rode out of Port-Au-Prince, Haiti, in a pick-up truck with a Baton Rouge Franciscan Sister at the wheel. The nun, Sister Althea Jonis, worked as a medical-missionary in the small Haitian village of Aquin. She had driven to the city to pick up Cindy Heine, a Baton Rouge Health System Vice President, and me from the airport. We flew in to create photos of Sister Althea's work.

About an hour or so out of town we rounded a corner and up ahead

we saw a makeshift roadblock manned by a lone gunman. He stood holding something that looked like an AK-47. Roadblocks were not uncommon during times of civil war, but military rule had been over for two years now. We supposed he blocked us from passing so he could rob us.

With no other choice, we slowed down to a stop. He headed our way, weapon in hand. I cringed.

Next I tried to become invisible by shrinking down into my seat, pulling my arms into my sides, trying to make myself smaller. I didn't know what Cindy Heine was thinking about, but the images that jumped into my head were from recent reports in newspapers about a Haitian practice called "necklace of fire" in which a tire filled with petro was forced around your body and then set on fire. I didn't see any old tires by the roadside. Being tightly sandwiched in the middle between Sister Althea and Cindy at least made me feel I was not alone in what might happen next.

I fixed my eyes on the gunman's angry demeanor. As he headed for the driver's side, Sister Althea cracked her window a few inches. Suddenly the same facial muscles that formed the violent look of a killer changed. They morphed into the tender look of someone who had just encountered an old friend. When the gunman saw Sister Althea's white headpiece, he recognized her as the medical humanitarian who had saved the lives of people he knew. After exchanging a few words in Haitian, he waved us on. I asked Sister Althea if she had extra veils in the back of the truck that Cindy and I could throw on for the remainder of the stay.

We had already passed one of the watering holes where we could have dropped in to get a cold beer to calm our nerves. On earlier trips Sister Althea would pull in for a beer after crawling through hours of hot steamy stop-and-go Port-Au-Prince traffic.

We were lucky that day. There was no civil war going on at the moment. Just the usual dangers. If we had been detained at a roadblock with a sister from one of the religious orders whose mission it was to serve those made poor because of war or economic oppression, I doubt the veils would have helped.

Roadblocks and being delayed for them usually ended badly.

Such was the case when Salvadoran military officers earmarked three nuns and one lay missioner for assassination in 1980. On Monday, December 1, 1980, Maryknoll missionary, Sister Ita Ford, was asked to do a reading for Maryknoll Sisters attending a closing liturgy at their regional assembly in Nicaragua. Sister Maria Rieckelman had clipped the passage for Sister Ita to translate and read from one of Archbishop Oscar Romero's final homilies before he was gunned down earlier that year in the middle of celebrating a private Mass in El Salvador.

Sister Ita read aloud to those assembled:

> *"Christ invites us not to fear persecution. Because, believe me, brothers and sisters, the one who is committed to the poor must run the same fate as the poor."*

She continued to read Romero's prophetic words.

> *"And in El Salvador we know what the fate of the poor signifies: to disappear, be tortured, to be held captive—and to be found dead."*[3]

The reading ended.

The Archbishop's warnings from the grave rolling off Sister Ita's lips to those assembled right there in that room were clear. The warnings were to those who would dare leave that assembly renewed and ready to return to their missions. They were to those who would dare to offer their lives in service to those made poor during times of civil war.

But those warnings didn't include the ignominious crime of rape.

The very next day, on Tuesday, December 2, 1980, Maryknoll Sisters Ita Ford and Maura Clark boarded a plane for El Salvador where Jean Donovan, a Cleveland Diocese lay missionary who trained at Maryknoll, and Sister Dorothy Kazel, an Ursuline Sister, waited at the airport to pick them up in order to return them to their emergency work in Chalatenango.

Meanwhile, an El Salvadorian National Guard Death Squad of five men also waited outside that same airport. They waited for orders from their commanders on how to proceed.

Another day passed and on Wednesday, December 3, the abandoned and burnt-up white minibus owned by the missionaries was found alongside the roadway. Some peasant farmers led the way to a cow pasture where they had been forced to bury the missionaries' beaten, tortured, naked, and raped bodies.

*Sister Ita Ford, Maryknoll missionary. Photo*
*courtesy of the Maryknoll Missionaries.*

*Jean Donovan, lay missionary for the Cleveland Diocese.*
*Photo courtesy of the Maryknoll Missionaries.*

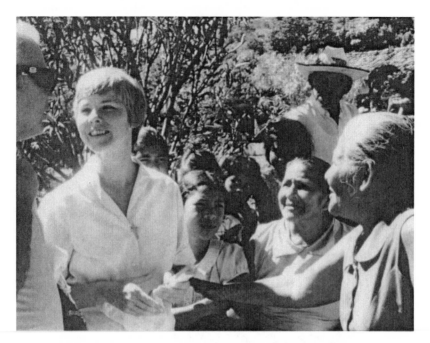

*Sister Dorothy Kazel, Ursuline Sisters of Cleveland, Ohio.*
*Photo courtesy of Ursuline Sisters of Cleveland, Ohio*

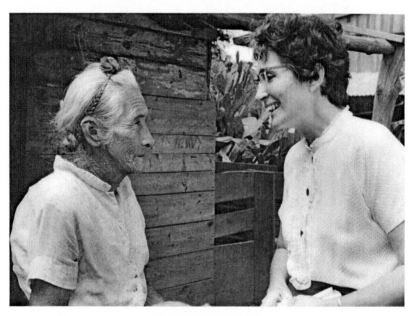

*Sister Maura Clarke, Maryknoll missionary. Photo*
*courtesy of the Maryknoll Missionaries.*

Perhaps 27-year-old Jean Donovan explained the position of missionaries working with war refugees best when she wrote to a friend a few weeks before her murder:

> *"The Peace Corps left today and my heart sank low. The danger is extreme and they were right to leave.... Now I must assess my own position, because I am not up for suicide."*

> *"Several times I have decided to leave El Salvador. I almost could, except for the children, the poor bruised victims of this adult lunacy. Who would care for them? Whose heart could be so staunch as to favor the reasonable thing in a sea of their tears and loneliness? Not mine, dear friend, not mine."*[4]

Sometimes it's difficult for missionaries to define their work and write home about it. Often there is no new building or center to show off to supporters because their mission is to search out the local needs and to adapt and be God's presence in the midst of some struggle. Such was the case when at the start of World War II, when two Japanese Maryknoll Sisters volunteered to live in the internment camps where Japanese Americans were relocated shortly after the attack on Pearl Harbor. Additionally, several American Maryknoll Sisters gave comfort by visiting the camps, though they were not allowed to spend the night.

In that same year that the four women were murdered in El Salvador, 10,000 citizens were also murdered. Because the country had not declared a civil war, the Red Cross could not step in to offer protections under international law. Five months before her death, Sister Ita wrote requesting that the International Red Cross in Geneva "recognize the "existing state of war in El Salvador so that international norms of behavior in times of war could be respected and overseen."

Under Archbishop Romero's leadership, the Catholic church had taken up the responsibility of providing humanitarian aid in various forms, including emergency work at Refugee Centers, even though there was no official state of neutrality that could keep people reasonably safe.

These centers needed workers. In essence, aid workers and missionaries were thrown into the position of being the first responders working with the poor. Not just the poor, but peasants made poor by a civil war. Nothing else could be more dangerous. Nothing else could demand so much of them.

These four women exhausted themselves by picking up dead bodies and giving them the dignity of a burial. In some cases, the bodies lay there with the loved ones looking on, afraid to tend to them, least there be repercussions. The women climbed into their vehicles to find refugees who had fled their homes and were now hiding-in-place, too terrified to move about to find food or shelter. These refugees were most often women and children. When they found them hiding, they brought them to the Center and went out to find food for them. In many cases their mission was and to simply be the church, in essence to be God, to a people who were terrified.

In her letters mailed home to her family and friends, Sister Ita Ford never begged to be rescued from the situation and brought home. She was like her cousin, Maryknoll Bishop Francis Ford, the same Francis Ford my great Aunt worked with in Yeungkong, who died in a Chinese Communist prison camp back in 1952. Sister Ita was only 12 years old when her cousin was martyred.

Sister Ita's only complaint writing home was that there was no break in the flow of violence that came into her life seven days a week. And even then her complaint was in the form of making a joke to cope with it all. Her sense of humor was preserved in letters to family and friends. In one letter she joked to her Mom, "I'm here at Maddie's Halfway House and pretending I'm in Bermuda." And in another letter to an old school friend she gave a picture of what daily life was like when she said:

> *"One day last week, I was in the coffee shop with a few people, when all around us everyone started toppling to the floor and crawling under tables. Of course, instinctively, we did the same and while I'm under the table, I congratulate myself that I meet threats quite nicely and after a few minutes we all crawl out and sit down and continue our*

*conversations. It seems that someone was running past with
a machine gun and no one cared to be the target. Then, life
goes on. The nightly shootings and the daily 'hearing tests,'
"Did you hear that?" "Yes." One night I burst out laughing
as well— "Yes, our ears seem to be okay."*[5]

When aid workers are murdered under these conditions, there often
comes the routine explanation from governments that the workers were,
after all, subversives or involved in subversive activities, suggesting they
somehow deserved what they got. Even had this been true, it would
not justify torture and rape. Nevertheless, this labeling operates to let
the perpetrators off the hook, giving the impression that the victims
deserved such violent deaths.

But in the case of the missionaries in El Salvador, too many people
knew better, and the family members of the missionaries would not let
it rest until the five guardsmen were sentenced to prison. Thirty-five
years later, this same dogged persistence that got prison sentences for
the five guardsman got the two military generals accused of ordering
the killings deported from their retirement in Florida and sent back
home to El Salvador.

Sister Althea Jonis and her co-founder Sister Martha Ann Abshire
of Baton Rouge could have been killed while on their Haitian mission.
Before they opened their medical clinic for the poor, the two Franciscan
Missionary of Our Lady Sisters went through a missionary training
program at Maryknoll in 1988 in order to be better prepared for the
rigors of missionary life in Haiti. They arrived in Haiti on a Thursday
and there was a coup d'état that Saturday by the Haitian military.

Sister Martha said that she lived through something like 13 changes
in government during the six years of service she gave in Haiti.

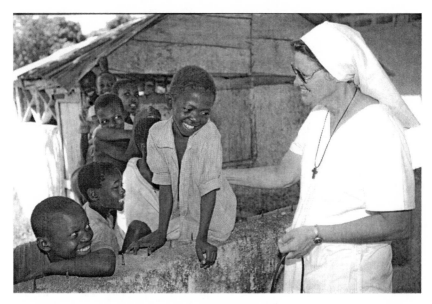

*Little boys gather on the fence at the clinic in Aquin as Sister Althea Jonis, Franciscan Missionaries of Our Lady, takes a break to tickle some of them.*

**Sister Martha Ann Abshire, OSF**

*Sister Althea Jonis makes a house call to an elderly neighbor,
Madam Andre. Madam Andre had about 17 beans in her pot for
dinner that night and a chunk of bread that lay on her dresser.*

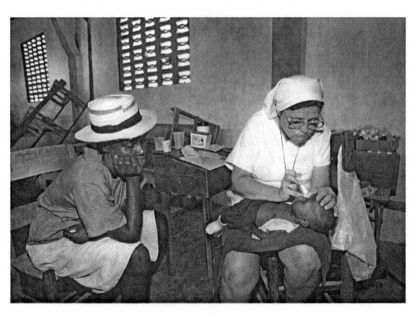

*This little girl came into a make-shift clinic set up in an old
schoolhouse with a 105-degree fever. She went into vascular collapse
and died. Sister Althea brought her back through resuscitation
and sat with her for hours trying to bring down her fever.*

Sister Martha said that on "one night, the week after a coup d'état against President Aristide, there was so much shooting in town we laid on the floor. We didn't know if the bullets were going to come through the house," she said.

There was a lot of torture going on during the years of unrest. In one day alone Sister Martha said she treated three victims who had their ears drums blown out from a technique where the torturer would come up behind them and cup their ears hard. If the victim wasn't giving the right information the intention was to intimidate. "If I never see another victim again in my life I will be happy," she said.

Sister Althea reported that the military tortured one man so badly that she could stick her fist into the wound on his buttocks. She would drive to the jail and treat his wound, and they would burst it back open. She would drive to the jail and treat him again, and they would break it back open again.

There were plenty of times when the locals told the two sisters they must not leave the house or travel to Port-Au-Prince to get critical medical supplies for their infirmary, lest they be ambushed or held for a ransom. While the Haitian military perpetrated violence on the people, the Sisters were not without a few trusted soldier friends. Sister Martha said that sometimes a soldier would show up at the clinic or the convent and say, "Sisters, the Commandant said it might be a good idea if you didn't go to Port-Au-Prince tomorrow." Sister Martha said the Commandant knew they had a routine of going to Port-Au-Prince on Tuesdays. "We never asked 'Why,' "Sister Martha said. "We would say, 'Thank you so much. Tell the Commandant we appreciate it.' And sure enough, we would hear there was something happening in Port-Au-Prince."

Sister Martha said that those warnings didn't stop them from getting caught in the middle of some stuff. They had backpacks ready to go should the day come that they needed to move quickly to another location. Sister Martha said, "Our Franciscan Sisters throughout the world do not abandon the people they serve. If our presence served as even a little deterrent to the military harming people, then that was what we needed to do."

The week before the US intervention in Haiti took place, Sister Martha said, they knew something was going to happen because on Voice of America they heard President Clinton say, "Sometimes you have to do the right thing, because it's the right thing to do."

Sister Martha said that the Haitian military was marching through the center of town and that there were anti-American slogans being shouted. "We brought supplies back from the clinic to our house: bandages, antibiotics, IV fluids, sutures, everything we thought we would need to deal with trauma. We had our people (employees at the convent) come. They brought their sleeping mats and they slept on the first floor downstairs while we slept upstairs. We had one gallon of gas left that we could run a small marine generator on and we had propane to cook with."

"We had a waning moon and I told Sister Althea 'Something's going to happen this weekend. The conditions are right.' That was Thursday night. Althea was almost totally deaf from her heart medicines, but I heard this noise because we were only a block from the bay. I told Althea, 'That's the motor of a big boat.' The next day people from the mountain came running down, 'Sister, there was a big, big ship out there.' So we told our people, 'they're planning something. It's going to happen this weekend.'"

That weekend the Voice of America announced that the Haitian General had agreed to step down and allow the US Special Forces troops to come in peacefully.

A few days later the sisters were told by a US Sergeant, "We were not going to have another Somalia." The Sergeant said that they knew exactly where the sisters' convent was. He said the US troops were within 15 minutes of coming in with full guns to evacuate the convent when the paratroopers were told to abort their missions and turn back because the Haitian military leaders were stepping down.

Missionaries have to grapple with the evil they see. Sister Martha said that she too grappled with the evil she saw. She said the Haitian people realize that evil comes from men, not God, and that the Haitians have a saying to cope with it all. "God is good and God is always good."

In a separate case of violence done to a missionary serving in times

of oppression, a Brazilian jury in 2010 found land owner Regivaldo Galvao guilty of ordering Sister Dorothy Mae "Dot" Stang's death, when he hired two gunmen to shoot her on an Amazon jungle road. Recently I sat down with two of her sisters, Sister Ellen Dabrieo and Sister Janelle Sevier, both Sisters of Notre Dame De Namur. They told me that Sister Dorothy, an American-born Brazilian, had been speaking for years on behalf of poor Brazilian farmers to protect the parcels of land they owned against illegal loggers and ranchers. She not only fought for human rights, she fought against the deforestation of the Amazon Basin. When her murderers took her life, it was on a piece of land that the government had granted to the peasants years earlier, but which the loggers and ranchers wanted.

Early one morning in 2005, Sister Dorothy headed out walking down a dirt road to a community meeting in Anapu where she would speak with poor farmers. The two gunmen hired by Galvao intercepted Sister Dorothy firing six rounds into her body. The first shot was fired into her abdomen. The 73-year-old nun fell face down to the ground. Next, the men fired into her back. Finally, the remaining bullets were fired into her head.

The two men fled, leaving behind the woman who belonged to a religious community that made it their life-mission to seek out and serve the poor found in the most abandoned places of the world. Those first on the scene didn't dare move her for fear of reprisals. She lay there most of the day while the forest's rain bathed the mortally wounded body of the person poor Brazilians settlers had come to call "The Angel of the Amazon."

*Sister Dorothy Mae, "Dot," Stang, Sisters of Notre Dame De Namur.*

Sister Ellen said that from its beginning, Sister Dorothy's religious order supported her work in Anapu, in the state of Para. She had been working in Coroatá, a city in the state of Maranhão in northeast Brazil. In the early 1970's, Sister Dorothy saw hundreds of families leaving her area in Maranhão in the hope of being granted a plot of land in the new settlement along the TransAmazon Highway. "These farming families were looking for a piece of land they could own and control," Sister Ellen said. "They had worked for generations on land owned and controlled by others, with no hope of ever moving out of poverty." Sisters Dorothy and Rebecca Spires went to visit this area along the Trans-Amazon highway and reported back to their community what they saw. The Sisters then gathered in Community deciding to send the two sisters to the Trans-Amazon area to begin to create community among these peoples.

People were arriving every day. "It was like the wild, wild West," Sister Ellen said. "Their hopes were soon dashed as they discovered

that the promise of land was not going to be fulfilled. Ranchers had fenced in thousands of acres of land for raising cattle. As the families discovered this reality, they moved up the Highway always in search of a plot of land," she said. "Sisters Dorothy and Rebecca moved with them, opening small schools, clinics and teaching sustainable farming methods to conserve the land. Finally, Sister Dorothy arrived in the area of Anapú where she settled and dedicated her life to the new communities in the area, especially in the settlement called Boa Esperança, a government sponsored Sustainable Project. Slash and burn and cutting methods to clear the land had already destroyed thousands of acres of land," Sister Ellen said.

While in Anapu, Sister Dorothy committed herself to teaching sustainable farming methods in order to preserve some of the world's largest remaining virgin forests where over 50 percent of the earth's plant species can be found, including plants critical for making medicines. Some speculate that 20 percent of our water runs through the Amazon River basin. The forest is said to absorb the majority of the earth's greenhouse gasses and it pumps out 20 percent of our oxygen.

Sister Dorothy once wrote to her family, "We must make great efforts to save our planet. Mother Earth is not able to provide anymore. Her water and air are poisoned and her soil is dying of exaggerated use of chemicals, all in the name of profit."

Sister Ellen said that "Sister Dorothy was stronger in life than in death because for more than forty years she also built schools, churches, and communities of faith where she taught sustainable farming and child nutrition. Her death brought the efforts to save the Amazon to light." Every year the magnitude of Sister Dorothy's work is remembered when hundreds of people, over a period of several days, make a thirty-five-mile pilgrimage that ends on the plot of land in Anapu where she was murdered. The villages along the route provide food and water for the pilgrims.

Today the Sisters of Notre Dame De Namur are still active in their efforts to help the poor in the most abandoned places. Sister Ellen said the sisters continue to identify and address practices and attitudes that

contribute to "making people poor and with the systems and policies that keep people poor."

Notre Dame Sister Janelle Sevier said that people can be made poor because others are unaware of their circumstance. Sister Janelle pointed out that "our history books are being re-written because we've been told it from only one side. There is another way to look at this," she said. "There is the slave view, as well as the slave-owner view. Whenever we are told of an event we hear it from a certain point of view. What we see or understand depends on whose stance we have embraced," she said. "It is always difficult to try and see things from another's point of view. When living and working with people made poor we try to hear what they have to say from their point of view and with an eye to identifying the root causes of the situation, not merely the symptoms."

Sister Janelle said that often when young people are given another point of view to look at, they will stand in that stance and try to make a difference. "The value of education is for people to make good choices, but for more than just me," she said.

In many cases, nuns serving the people during times of conflict don't walk away from their missions. It's not that their organizations don't ask them to come home because of the dangerous work they do, it's that often they can't be convinced to leave. Some even minimize just how precarious the situation is because of their desire to stay and serve people who are enduring unimaginable suffering. In Sister Dorothy's case, her name had been seen on the top of a death list reserved for those who advocated against the practice of clear-cutting the trees and burning the forests to make room for things like logging, soy beans and cattle grazing. Additionally, someone had placed a bounty of more than $20,000 for her death. Because of her murder, Brazil's president put eight and a half million acres under environmental protection in addition to creating two new parks and suspending logging in areas that were being fought over.

In the short history of American Missions, while many women religious have died a natural death serving the poor, many also have been martyred, led down a public street naked to be torched, to be

strapped down onto a board and have water poured over the cloth on their face, to be beaten, to be starved or imprisoned until their release.

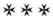

*Back in Calcutta*--Mother Teresa's sisters moved quickly to get us to Dum Dum, their compound a few minutes up the road. Since we didn't want to push our luck with the curfew, and the streets were too dangerous to risk venturing deeper into Calcutta, we would spend the night there.

At Dum Dum, a sister showed me to my room, which measured eight-by-ten feet. In one corner, taking up most the space, stood a single bed with a simple rusted frame. When I sat on the bed, the lumpy looking mattress pad made a crunchy sound, making me wonder what they had stuffed in there. Two chairs and one little table shared the remaining space along with a storage area for bedding. A ceiling fan hung over my bed. Since my bed had no netting, I later found the fan useful for blowing off the horde of mosquitoes waiting to devour me.

Before my journey, Sister Sylvia had told me that most of the world bathed in a bucket. In a few moments, I would too. The nun who showed me to my room disappeared into the cool night, emerging fifteen minutes later with an aluminum bucket filled with several gallons of warm water. I inspected my bathroom, noticing the floor sloped to a small hole in one corner that led to a gutter outside. How to take a bucket bath became obvious. I began splashing warm water onto one arm and tried working up some lather. Still the ritual was slow, and my body shivered in the chill. Frustrated, I stood in my bucket with both feet. My body became like a palm tree waving in the wind as I swayed to and fro. My size ten feet struggled to keep me in balance. I began pouring water from a little red cup over my head. That worked better.

As I stood with my feet in the bucket, a bar of soap in one hand and a washcloth in the other, someone walked in on me.

The intruder asked whether I would take some tea and bread. Still standing in my bucket, I replied dryly, "I don't think so."

"Are you sure?" she persisted; only wishing to make me feel at

home. "I'm really not hungry now," I said, hoping she would hurry up and leave.

Cold, tired and a little homesick, I dried off, put on my pajamas, and climbed under the brown sheet and wool blanket that covered my bed. As I lay there taking in the new smells and sounds of this strange country, mosquitoes on refueling missions drifted through my two glassless windows. Moaning from women and children also drifted in. I wondered what type of work the nuns did here. The moans coming from the windows were unsettling and in my mind I began to see the beaches of Cozumel. I thought of the scuba diving trip I took there a few years ago and I wondered if this trip was a mistake.

Maybe I should have gone diving instead, or to Alaska chasing whales on one of those two-week adventure trips I always wanted to take.

Finally, my mind became quiet. I said my prayers, remembering to ask my Bishop, Stanley Joseph Ott, who had died of cancer the week before, to pray for me. I held my rosary in my hand and fell asleep.

The next morning, on the drive to the Mother House, I saw families living inside huge abandoned drainage pipes alongside the road. In those days, Calcutta packed over three million people into forty square miles, giving it a population density of 82,000 people per square mile. While parts of the city prospered and led the nation in jobs and commerce, the slum area was decidedly another world, where one million people lived either on the streets or in tiny single story huts with no sanitary facilities.

I saw children, covered in filth, standing alone on the streets. One girl, about six or seven years old, urinated on the sidewalk while her younger sister stood barefoot in the stream. Poverty shows mercy to no one, I thought. I just sat there in silence unable to speak.

The suffering made me recall some of Mother Teresa's first words to me months earlier when I had spoken with her on the phone. In the summer of 1992 I drove Sister Sylvia through Texas, finishing a three-state tour where she made her annual visits to the convents in her region. The week before, Sister Sylvia had called me from San Francisco asking if I could take a few days off work to drive her and a couple of other sisters in their big van. I told her I could if she would let me rig up a

portable antenna onto the roof of her van so I could stay in touch with my clients on my new cell phone. Sister Sylvia agreed, but not without teasing me that I couldn't be separated from my technology for only a few days.

During the next few days, I used the phone sparingly out of respect for the sister's simple lifestyle. On the second day of our trip, Sister Sylvia wanted to know if she could borrow my phone to make an important call.

Stunned, I gave her a look and quietly handed over the phone. She made her first call and when she finished that call she made another, and then another and another. In the middle of one call that lasted about twenty minutes I interrupted her, taunting, "You've got to get off of that phone!"

Sister Sylvia was from Southern India—Kerala. When Mother Teresa was younger, she knew the family well, and used to stay overnight in their home. Sister Sylvia was just a young girl at the time. When she came of age, she joined Mother Teresa as did her two siblings, Sister Stella and Sister Marie Lucy. The word was that Mother Teresa loved Sister Sylvia like a daughter and that wherever Sister Sylvia was, sooner or later there would be a visit from Mother Teresa. Usually the visit was to open a new house, or to be there when the sisters made their vows.

I could understand why Mother Teresa loved her. While she had to be wise to avoid the pitfalls that come with leadership, her actions were not that of a bureaucrat. She was never a lover of rules, but of people, yet religious life had plenty of rules.

One time, around the Christmas holidays, Sister Sylvia took some nuns under the cover of darkness and went out onto the streets looking for drunks and the homeless asleep on the sidewalk or living under overpasses. Without saying a word or disturbing them, the sisters quietly covered them with blankets. They didn't cover them because they were cold. They covered them so that when they awoke in the morning they would feel like somebody loved them.

On the way home from visiting the convents, we headed towards Louisiana passing through a very boring stretch of Texas on Interstate 10. Sister Sylvia broke the silence.

"Marie. Why don't you call Mother?"

I gave Sister Sylvia a confused look because I had just visited my mother the day before as part of our trip. While Sister Sylvia visited one of the houses in Little Rock, Arkansas, I took the sisters' van and scooted up to Rogers, Arkansas, to see my mother. After twenty-three years of marriage, Mom and Dad had split up and remarried after the car accident that killed my little brother Karl. Mom was now living in Rogers.

I replied, "Sister, I was with my mother all day yesterday." She said, "No Marie, Mother." I said, "You mean 'Mother' as in Mother Teresa?" "Yes," she said.

My heart started to pound. In disbelief I replied, "Yeah Sister. I'm going to just give Mother Teresa a call in India from my cell phone and say, "Hey, 'Mother.' This is Marie from Louisiana. I'm driving around with your sisters in Texas and just wanted to say hello."

Sister Sylvia said, "Marie, call her and ask for a blessing." "Oh." I replied. "I can do that."

Sister Sylvia pulled the number out of her purse and I called, but we couldn't get through.

As soon as I got back home to Baton Rouge—with Mother Teresa's phone number in my pocket, I raced up several flights of stairs—the elevator was too slow—sometimes overtaking two steps in a single leap in order to get to my fourth-floor apartment. I caught my breath and inside the quiet of my apartment calmed myself, and then I called Mother Teresa on the landline.

It was common for Mother Teresa to answer the phone at the Mother House in Calcutta. They had only one phone and it was in her office. When I called, I recognized the voice on the other end from having heard her speak in New Orleans years earlier.

She said a simple "Hello." She didn't say, "This is Mother Teresa," or try to identify herself in any other way, just a quiet "Hello" came out in a deep alto voice.

"Mother, this is Marie Constantin from the United States. I've been driving Sister Sylvia around the country to visit the convents and she told me to give you a call.

"Oh! Sister Sylvia," she said." "Isn't she a beautiful sister? How is Sister Sylvia doing?"

"She's great Mother. We love her over here."

"Please tell her hello."

"I will do that Mother."

"Thank you for helping my sisters," she said.

Suddenly the line got quiet and there was a long pause....

Changing the subject, she said to me, "So much suffering in the world."

It disarmed me. I forgot to ask for the blessing. She said the words wistfully. She said them kind of like a beggar would say them, as if I should do something about it. It was strangely intimate. It had a call to it. I couldn't taint the moment by making small talk. We ended the call and it left me feeling haunted by how personal it felt.

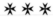

*Back in Calcutta*--Finally, our vehicle reached the Mother House, a large four-story box-like cement building slapped right in the middle of the slums on 54a Lower Circular Road. In 1953, Mother Teresa moved in with her little band of sisters after having lived for four years on the upstairs floor of a Bengali family's home.

The building housed the administrative arm of the 4,000-member organization and gave up every square inch of its space to the 200-300 nuns who lived there.

While some took up permanent residence there to service the order's many facilities throughout Calcutta's slum area, other sisters flew in from all over the world, only to touch down and pass through while on their way to a new assignment or a home visit. And some sisters arrived for additional training and instruction.

During the holidays, the Mother House had the feel of a Calcutta train station. While the upper floors of the old building bulged with sisters, the open-air patio area on the first floor overflowed with volunteers, as did a tiny room containing a table and a few chairs.

Each day brought new volunteers from all over the world. I bumped

into volunteers from countries like Iceland, Germany, Switzerland and Japan. At any given time there seemed to be a hundred of them working and living all over the city, all ages, all faiths, and some with no faith.

They came to the Mother House to meet up with one another and to get their assignments. Some brought with them sophisticated medical skills, most offered only the labor of their hands.

If you got there early enough before the start of day, the sisters would bring in some sweet tea, some bananas, some bread and oil to pour over the bread. The oil served to keep your hunger away longer as you went about your work assignment, which often included physical labor.

While some volunteers came with advance permission from the sisters, others simply arrived at the convent doorsteps, sleeves rolled up and ready to work. The younger ones would sometimes stay six months to a year, helping at the different ministries all over the city. Many of them were still teenagers, their smooth shiny faces filled with that wide-eyed wonder and abandon that must have brought many a sleepless night to worried parents back home.

It seemed most volunteers flew into Calcutta alone. Because of that, they were eager to make new friends. Lunch and evening mealtime provided that opportunity. Volunteers formed their own communities by meeting for meals in the various restaurants sprinkled throughout the slum. When you walked into a restaurant and saw volunteers, it was understood that you would grab a chair and join the group. Chances were enough people at the table spoke a language close enough to yours to hold a conversation. If you missed a few words, the others at the table would translate and fill in the gaps. There was always a lot of translating that went on during these meals.

Some volunteers had the inside scoop on what day and time Mother Teresa would speak in the convent chapel to the volunteers or whether she was abroad or back home at the Mother house.

One afternoon Mother Teresa spoke to a large crowd of volunteers in the chapel. She told them to "thank God for the joy of loving with the sick, and the dying, and the crippled, and the mental, what a beautiful opportunity you have," she said.

She said that "When you get together with family, even when you have misunderstandings, get together. Forgive and forget. And you will be really filled with God's love. Really have the peace of God in your heart. This is very important," she said.

Newer volunteers looked lost or bewildered by the conditions on the streets. The veterans often helped the new arrivals adjust.

Upon my arrival to the Mother House, a nun took me upstairs to meet Mother Teresa. I walked up the first small flight of steps, up the next flight and rounded the corner to the left. There she was—standing out in the hall greeting a small line of people. She was barefooted of course.

Mother Teresa was vibrant, moving about, cracking jokes. When it came my turn to see her, I gave her a gift from my bishop. Mother Teresa took my hand in hers and touched a rosary I held out that Sister Maria Rose had made for me. My mind became quiet and my lips didn't want to move. I just wanted to be with her and be still and hope the moment would last forever. In the years ahead, this is how it always was with me. I could never probe her to answer my deepest questions. I would just look at her, make photos, and become very quiet while others asked the questions.

After my visit Sister Josema, the person in charge of volunteers, gave me a work assignment and settled me into a Baptist mission a few minutes up the road. The mission, owned by the Baptist Missionary Society, provided missionaries of all faiths rooms at good rates. My seventeen-day stay, which included breakfast, totaled $60. The room had five beds and at various times I shared the space with a young atheist from Switzerland, a pediatric surgeon, and two teachers passing through. The two teachers arrived during the middle of the night and that was when I realized I was paying for the use of a bed and not the whole room.

The first night at the mission the atheist and I heard seven gunshots. A few hours later four more shots rang out. We wondered aloud whether the bullets hit their target.

The next morning, stepping outside the safety of the mission's eight-foot-high walls, the horror of Calcutta's slums yelled good morning

to me. Heading to the Mother House for Mass, I picked my way through families still asleep on the cold cement sidewalks. Bands of small "beggar boys" began forming. Soon they would walk the streets looking for scraps of paper to sell as fuel.

People cooked on the streets, making small fires with dried dung. Mothers began the morning ritual of running their fingers through their children's hair, pulling out lice. Men took baths at the public water pumps.

After Mass I picked up the atheist and we walked to an orphanage, our first work assignment. Here the nuns cared for children who were sick, abandoned or living there while their parents recovered from financial problems. My first job was to entertain about six toddlers who had to sit for fifteen-to-twenty minutes on little plastic portable potties for their training.

One little boy showed me his tonsils as he bawled loudly, hoping I would rescue him from the boredom of the ritual. I reached to lift him, but he had no arms.

Startled, I put my hands where his arms should have been. He stopped crying, I took my hands off. He started screaming again. I put them back. He stopped. Feeling foolish, I started to sneak my hands off. He screamed louder than ever. Quickly, I put my hands back on his little empty stumps, sat on the floor with him, and for fifteen minutes, tried not to cry.

Though the sisters' work saved hundreds of children from disease and hunger, their efforts were never enough. The newspapers reported stories of women selling their children. I read about one woman who got a little more than ten dollars for her daughter. The paper reported that after one child died of malnutrition, the mother sold her other child to buy food for her remaining two children. Later I would learn that this practice of sacrificing one child to save the rest happened frequently where food was scarce.

Twice I set out to take pictures of the children living on the streets, even hiring a guide, and twice I canceled. It was too horrible. I didn't want to photograph it. I could walk around photographing the filth and the misery, the mentally ill, the orphans, those without legs, or those

without jobs or those ostracized or abandoned by their culture, living on the streets, or I could do little things that meant something to just one person at a time. At one facility, an old woman lay on her cot and when I passed by, she asked me to find her a blanket. I went and found a wool blanket and sat down on the edge of her cot as I covered her and rubbed her arms and her hands, trying to help her to get warm faster. I gazed deeply into her eyes letting her know I cared about her. And she looked back at me, and knowing I was just a volunteer, asked me, "When are you leaving." The words were hard to get out because I didn't want to go. "In a few days," I told her. We both became quiet and I did what I could for her.

## Chapter Five

# "POVERTY IS NOT JUST FOR A PIECE OF BREAD"

**B**LOOOOOSCH!!! THE VOLUNTEER DIDN'T WASTE time as he dumped an ice-cold bucket of well water over a six-year-old's head. It was Sunday, the day the volunteers rode a bus across the Hoogly River to help Mother Teresa's order of brothers bathe a crowd of "beggar boys."

The water sent chills down the naked boy's body, and I laughed as he squirmed in my arms.

Then, BLOOOOSCH!!! The second bucket of cold water hit me in the head. It took my breath away. The little boy giggled, and I loosened my grip. Suddenly, he bolted. Like a bullet from its chamber, he was gone from my arms, hidden among the sea of brown faces awaiting their bath.

But then I spotted him shrieking and dancing with joy and delight at his escape. His location was revealed. The chase began. Finally, other volunteers joined in on the merry chase and we swooped down on him and finished the job. We had one down and over a hundred to go.

Scanning the crowd, I spotted two little boys standing off to the side, under a tree. Walking over, I asked the older one, he appeared to be around seven, if I could help bathe the two of them. He probably could have done it himself, but he happily agreed. When it came time to remove his little buttoned down shirt, he hesitated.

I saw that a button had been left undone mid-way down the shirt and he seemed to be protecting a small lump hidden inside his shirt. Finally, he leaned in, looking about at the other little boys, and he whispered to me that he couldn't remove his shirt. "I have dinner for tonight in here for me and my brother," he told me.

I assured him I would keep the food for him safely in my backpack and return it after his bath. He handed over a white napkin and upon peeking inside the folds I saw a little pile of rice, about a cup-full, with some yellow gravy over the top of it.

One morning the atheist and I worked at Kalighat or the Home for the Dying. Here the sisters cared for dozens men and women in critical condition, not expected to live. By the time the nuns picked these people off the streets, they looked like survivors of Auchswitz. A sister joined me as I struggled to get my first patient, an old woman, into the bath area. With the woman sitting naked on a cement ledge, the sister poured a bucket of cold water over her head. Unhappy about the bath, the old woman began to hit me, but her blows had the force of popcorn bumping the top of a lid.

That night at the mission, the atheist asked me if I cried that day. "No," I said

"I did," she confessed. "I would wash a patient, and then go up on the roof to cry. I would go back down, wash another, and then go back up on the roof to cry. I can't stop crying," she said.

A few days passed when the she told me she needed to find another place to live. Every morning at breakfast the missionaries took turns praying over the meal and she figured her turn was coming up. She seemed panicked about it all, panicked enough that she wanted to move out. She had found a place that rented beds for just a few bucks and she wanted to know if I wanted to join her. I declined and later regretted losing track of her. I never ran into her again.

Calcutta amazed me in the diverse group of people who came to help Mother Teresa. A Jewish optometrist from San Francisco flew in one day. A bunch of us were scheduled to take a train and go sing Christmas carols for some folks suffering from leprosy. "Silent night, holy night, all is calm and all is bright," we sang. I looked over and our

Jewish friend sang as loudly as anyone. Clearly he only saw the suffering a disfiguring disease inflicted on the people in front of him. He rose above any ideology that might have stopped him from joining in.

My favorite day in Calcutta was spent praying in the Contemplative sisters' chapel and photographing a wedding for an Indian couple that couldn't afford a photographer. When the nun in charge, Sister Fatima, asked me to photograph the wedding, I had no flash and only thirteen frames of film on me.

When we got to the church, I learned the electricity had been out for a week. The sisters helped me open all the doors and windows, barely giving me enough light. During the ceremony, Sister Barbara, not knowing that I was low on film, kept signaling me to take more pictures. As the wedding progressed, the sun seemed to race for the horizon, taking with it my precious light and forcing me to choose even slower shutter speeds.

Toward the end of the ceremony I searched for pillars and solid objects to brace myself against, trying to make my body into a tripod so the slow shutter speeds would stop the action. As it turned out, the subdued colors from the underexposures were rather nice.

While the women serving in Mother Teresa's active order of nuns concerned themselves mostly with alleviating physical poverty like hunger, disease or homelessness, Mother Teresa often spoke about another kind of poverty, a greater poverty, a poverty often found in the more developed countries, a poverty found deep in the soul. This poverty makes us too busy, too busy to spend time with each other and too busy to spend time with the family. And like hunger destroys the body, this poverty destroys the soul, the family and society.

"Poverty is not just for a piece of bread," Mother Teresa told a New Orleans crowd in 1984. "Poverty is in our hearts when we don't have time for each other. Do you know the poor of your city, of your neighborhood—maybe your own family? Somebody is feeling sick. Somebody is feeling lonely. Somebody is feeling worried. Are you there? Do you have time? Are you there?"

Quickly my eighteen days in Calcutta melted away, leaving me sad

at thoughts of going home. "This is crazy," I thought. "I should hate it here. Why don't I hate it here?"

Then I remembered my last conversation with Bishop Ott as he lay dying on his hospital bed. Mother Teresa's Sisters in Baton Rouge had asked me if I would drive them to the hospital to visit him. He lay in the bed hardly able to move as I told him about my upcoming trip. "Calcutta is a very holy place," he told me. "I wish I could go there."

Maybe this is a holy place, I thought. Maybe it's holy because it's one place on Earth where people like me and the atheist can finally see our own poverty. However, the thing that makes our poverty go away is not food or clothing or amassing fortunes, but sharing our lives in a way we hadn't thought of before.

CHAPTER SIX

# THE CALLS STARTED COMING

IT WAS IN THE MIDST of the three trips to India that the phone calls started coming.

"Marie. Mother's coming!" Sister Sylvia would say excitedly from her New York convent in the Bronx. "You come and take pictures."

I would tease with a mild protest. "Sister you are going to make me go broke with all these trips you want me to take!" Of course I couldn't book my flight fast enough.

"Marie, why you need all that money?" she would scold back in her broken South-Indian accent.

"You come! Bradley is coming and Michael…. You come."

When I first met Sister Sylvia she was in charge of all the convents in the Western half of the United States. Now she was Regional Superior for the eastern part. Nothing made her happier than a visit from "Mother," as the sisters lovingly called her.

When Mother Teresa came to town, I wasn't the only one to get the calls from Sister Sylvia. She would call Michael Collopy, a San Francisco photographer and volunteer; Bradley James, a Palm Springs musician and restaurant owner; Father Steve Meyers, a San Francisco priest, and Sandy, Jan, and no telling how many others she would call to do little jobs.

While Mother Teresa's main focus in coming to the United States

was to preside over her sisters professing vows to religious life, all of us had our jobs to do to help out with the ceremonies. Michael and I would photograph the professions, as they were called, so that the sisters whose families couldn't afford to make the long trip to the US would have photos to send home. After the events, Mother Teresa would stick around for sometimes more than a week. That's when Michael and I rode around in the vans with the entourage and continued to make photos behind the scenes.

There was plenty of down time to drive up and down the east coast visiting the other convents and speaking to people. Sometimes Mother Teresa would be in the States for weeks at a time caravanning around from convent to convent. Whenever I got to go I slept wherever I could, in the convent's guest rooms, on a cot rolled into the sacristy, in a dormitory at one of the facilities, anywhere.

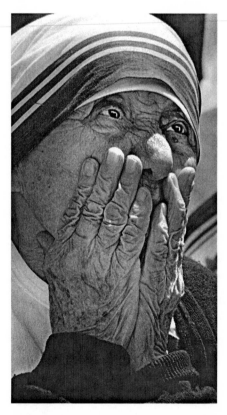

*Awe--Mother Teresa reacts to a man talking to her.*

*Peek-a-Boo--We were wasting time at the airport, waiting for Mother Teresa's flight to depart, when the sisters, two-by-two, began sitting down next to her so I could snap a photo for them. As soon as I took the photo, the sisters sitting down jumped up, allowing another two sisters to dive into the spot for their turn. There was a lot of laughter in the room and for a split second Mother Teresa playfully covered her eyes.*

*Saying Goodbye--One day we drove down from New York city to Charlotte, North Carolina to visit the sister's there. The sisters had just opened a new house, Mother Teresa had spoken to 16,000 people in a large auditorium, and now it was time for the sisters to say good bye to her. People came to Mother Teresa taking away what they needed. Her sisters were no different. Some sisters were in awe of her, some wanted something from her, others squealed in delight to be near her.*

*Everybody Get Wild and Crazy--Sister Sylvia, the Regional Superior, asked me to take a group shot of the nuns who had been on retreat. When I finished with the serious shots, I hollered, "Now everybody get wild and crazy!" And this is what they did. Sister Sylvia is in row two, fourth from the left end.*

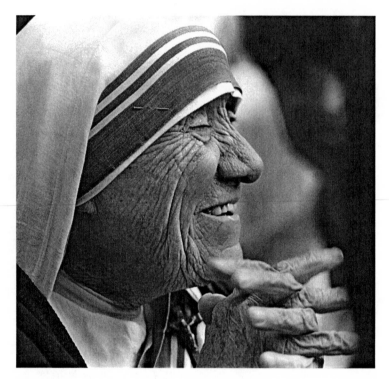

*This Moment, Wonderful Moment--In the midst of all the suffering she
saw, Mother Teresa found joy. If she didn't find joy, she could easily create
it right on the spot. She would often make jokes and then laugh at her
own jokes. They were most often silly little one-liners thrown out to pull
you into the moment with her. One time—after telling a little story—I
saw her whole body collapse into itself, she was laughing so hard.*

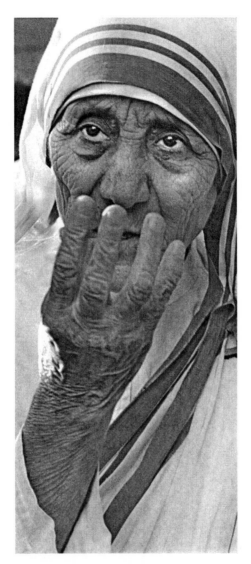

*Telling Stories--1995 marked Mother Teresa's first visit to Baton Rouge. When she went to the mic, she began telling stories. This image is from the same roll of 36-exosure, TRI-X film that the Beatification photo came from.*

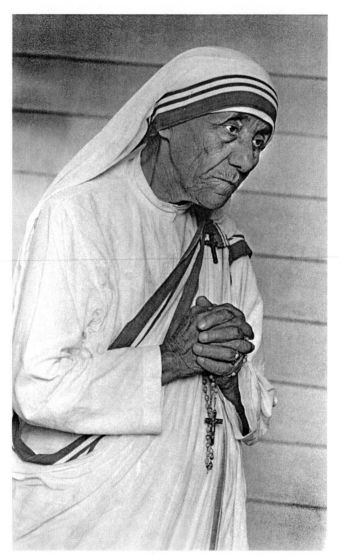

*Praying--Mother Teresa was praying during a ceremony to open an un-wed mothers house in Baton Rouge.*

*Bronx Convent—Mother Teresa is followed by Sister Sylvia and an entourage of sisters at the Bronx convent in New York.*

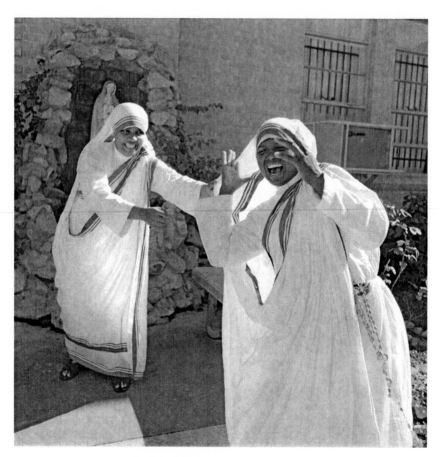

*Too Shy to Pose--Sister Melrose grabs Sister Lucenta
and pulls her in for a photo shoot.*

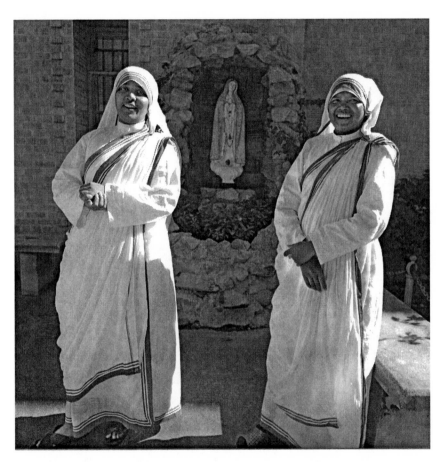

*Outtakes--Sister Melrose and Sister Lucenta posing for a photo shoot.*

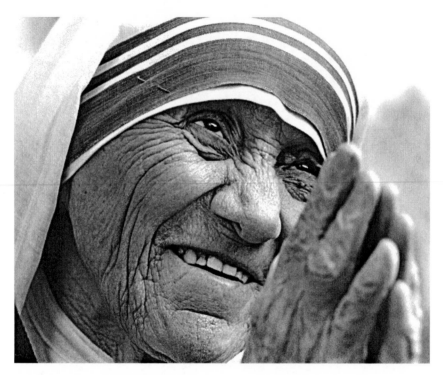

*Lotus--Mother Teresa would often clasp her hands together taking a bow. Gandhi was known for this gesture. The gesture is traditional in many Eastern cultures and substitutes for a hand shake, but has additional meanings of peace attached to it.*

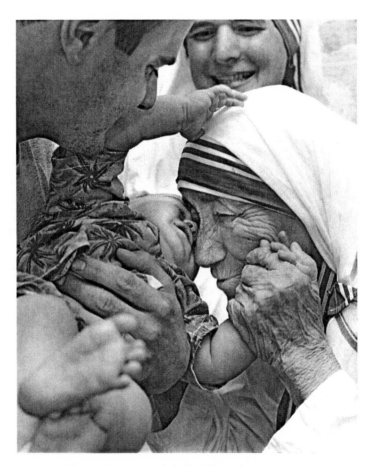

*Bronx Convent-- Mother Teresa has a moment*
*with Sister Margaret Joseph's relatives.*

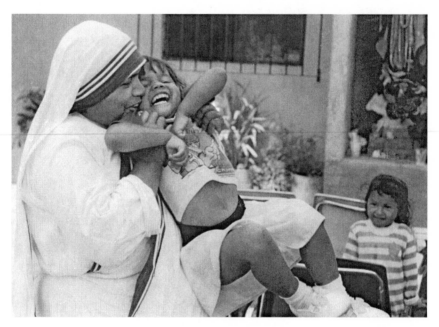

*Tijuana--a little girl patiently waits her turn to be loved by Sister Maria Rose.*

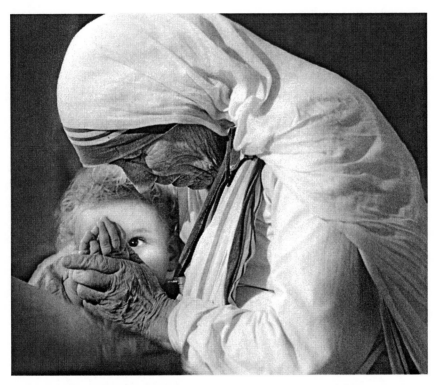

*Mother and Child—Mother Teresa was speaking at a press conference
when this small child interrupted her for a moment. Mother Teresa grabbed
the child and brought her in close to say a little prayer with her.*

On one trip Father Steve, Bradley, Michael and I met in Washington DC and rode down together in two vans to Charlotte, North Carolina, where Mother Teresa spoke to 16,000 people in a local auditorium. On the drive home we stopped at the Roy Rogers rest stop to eat, but Mother Teresa and the sisters stayed in the van. The sisters didn't eat in restaurants. They took their meal from the basket of food they brought along.

People went wild when Mother Teresa came to the US. Some got out of control, pushing, shoving and fighting. Others would scream and yell and get very angry if someone got in their way.

Some waited in long lines, hoping they might get to meet her. Usually they got their wish. Usually if someone showed up on her doorstep, wherever she was, she would see them. If they wrote to her, she wrote back. I told a friend of mine who had cancer to write to Mother Teresa. A few months later, she got a letter from Mother.

I remember one-time Mother Teresa was feeling very ill. She had a high fever and was resting in bed and it seemed that nobody was going to get to see her. There was a huge crowd gathering in front of the contemplative sister's Union Avenue convent in the Bronx. Bradley had been mingling with the crowd. Bradley grabbed me and said, "Marie. There is an old woman in the crowd. She's wearing black. Her husband died yesterday. We've got to get her in to see Mother!"

Sister Sylvia and all the sisters loved Bradley. He was always thoughtful like that. He would go out into the crowds and make sure that people with special needs had a chance to see Mother.

I loved Bradley too, so much that I named my cat after him. I named my other cat after Sister Ancy.

Bradley and I pushed through the crowd to the old woman and slipped her through the convent door where she told the sisters her plight. When they told Mother Teresa the woman's husband had died yesterday, Mother Teresa got up off her bed and came out to see her. She spoke a few simple words of comfort to her, nothing profound, just a few words. I stood watching as the old woman's face, all crunched up in anguish, relaxed and returned to peacefulness.

Another time we were in New Jersey and we were short on police

officers. Mother Teresa must have been frail that day or there must have been some concern for her safety because Sister Sylvia asked me if I would protect Mother's left side. Michael watched the right. He and I set our cameras down and stood on either side of her at the foot of the altar as she spoke some words into a microphone at the close of the Mass. When she finished telling stories and speaking, she stayed to greet the hundreds of people who formed a line to meet her.

Mother Teresa stood there and would not leave until she had seen every person who wanted to see her, which, of course, was everybody. After what seemed like an hour, my feet were killing me. I looked down at my feet and saw Mother Teresa's feet just inches from mine. Her left ankle was swollen to twice its size.

On another occasion I was staying in the Washington D.C. facility for people with AIDS. It was late at night and I was nearly asleep in my dormitory-style room when a physician and another volunteer entered my room on the way to their rooms. They stopped at the foot of my bed and began discussing how much pain and discomfort Mother Teresa was having in her neck. The next morning when I saw her with the people she was as generous as ever—kissing and handing out the little silver miraculous medals she was famous for handing out and seeing every person who came. While she loved people and lit up when she got to be around them, people never knew of the physical discomfort she sometimes endured to be with them.

When she walked into a room that had a small crowd, the jokes started flying. She was good at one-liners and it seemed as though nothing made her happier than to see that she made someone laugh. Most of the time the jokes were about nothing, just the silliness of everyday life.

One time a couple of us were sitting down at a tiny table located in the Sacristy in the Bronx convent. When Mother Teresa rounded the corner and saw us sitting there, she came in and sat down with us. It was rare to see her stop long enough to sit down, but this day she did. She started making jokes and when she got to her punch line everyone laughed, and then she laughed. She laughed so hard that one of her hands came down hard slapping her knee. Next, her whole body

followed by folding in half at the waist while her face collapsed into her lap. For a moment she couldn't sit up straight she had wrapped herself in so much laughter.

But when she began telling stories about her work, she became somber.

I wondered how she could be so happy with all the human suffering she saw and all the sad stories people kept telling her wherever she went. Yet she seemed to know her limits and she knew how important it was to be in the present moment, not worrying about the past or the future, or worrying about things she couldn't do anything about. She seemed to see what was right there in front of her and nothing else.

Western thinking doesn't encourage us to live like this. Yet, when we are not fully present to all moments, when our minds drift off to the future or try to relive the past, we risk missing the will of God in a lost moment intended for us. If people were lucky enough to be in Mother Teresa's path, they got her full attention whether they were dying in the street or simply needed a listening ear.

She did not lose her effectiveness and become paralyzed with the enormity of all that she could not do. Instead, she was joyful and focused in the little that she could do. She did one thing at a time. If she saw someone dying in the streets and she had the means to take them home with her, she took them home, not feeling guilty about all the ones she saw on the way home that she couldn't pick up. "If I hadn't picked up the first one, I wouldn't have picked up 42,000," she often told the crowds that gathered.

Mother Teresa's simplicity was disarming. When she went from place to place she carried her whole wardrobe with her in a medium-sized hand-made cloth bag that she called a purse. Her entire outer wardrobe consisted of three sets of clothing "one to wear, one to wash, and one to mend," as she described it.

Her convents were almost as sparse as her purse. There were no couches or TVs, and no over-stuffed chairs to fall into at the end of a hard day. Her sisters lived dormitory style and the dining areas were furnished with long picnic tables with benches.

Convent life and religious life were kept simple for many reasons.

The sisters took a vow to give "wholehearted and free service to the poorest of the poor." In order to give free services, they themselves had to live simply—making many personal sacrifices. Mother Teresa's philosophy was that the less you have, the freer you are to give. She chose a hard lifestyle. Some of the women who followed her did well with it, while others found it was not for them.

Someone asked me what motivated Mother Teresa to live the way she did and to want to go out onto the streets and help people. I can only guess from her own words that she saw God in others and especially in people who suffered. She often referred to God as a person who comes to us in disguise. She used to say "The dying, the cripple, the mental, the unwanted, the unloved, they are Jesus in the distressing disguise of the poor."

In Mother Teresa's mind, if a person gave someone a smile, they gave it to God. If they were kind to someone and did a small thing for them, they did it to God. One time she grabbed my hand and said: "Five fingers. Remember! Five fingers. Remember!" And as she moved across my hand with hers, pinching each of my fingers starting from my pinkie and working her way towards my thumb, she assigned a word to each finger: "YOU, DID, IT, TO, ME," she told me looking deeply into my eyes and repeating herself, while at the same time giving me a tool to remember the lesson. In the Gospel of Matthew 25:40, the Bible quotes Jesus as saying, "Whatever you did for one of these least brothers of mine, you did for me."[6]

My favorite story about Mother Teresa came from my friend Michael Collopy. He was in Calcutta photographing Mother. When he finished his business at the Mother House he headed down the street, walking toward his hotel. Suddenly he realized he had forgotten a package and so he had to double back. By the time he walked back to the Mother House, it was the sisters' private time. Usually they didn't let anybody in during that time; however, someone forgot to lock the front door. Not knowing any better, Michael wandered back into the Mother house. As he entered the front door, he made his way unnoticed and turned to the right, climbing the stairs that led to Mother Teresa's office. He peeked through a window into Mother's office to ask about his forgotten item

when he saw something he wasn't supposed to see, something few on the outside would ever witness. There was Mother Teresa on her hands and knees, she was in her mid-80's, she had a bucket of water on the floor next to her and a rag in her hand. It was time for the sisters to do chores and she was doing her part by scrubbing her office floor.

Some would not understand this. Those of us with Western minds might think, "What a waste of time. Mother Teresa should have been out feeding the poor, or speaking to large crowds, or meeting with dignitaries, or praying!" Yet, in Mother Teresa's Eastern mind, all of life was holy. Every act was holy, every chore done in the right frame of mind...holy.

Performing little everyday tasks with love was, to her, as good as doing larger, seemingly more important ones.

My time with Mother taught me that holiness is more than some celestial act a mortal manages to perform, or a posture we take during prayer, or the religious garb we decorate ourselves with, or a ritual, an ideology or a moral judgment.

Holiness is made up of everyday stuff—like cleaning the shrimp, and taking out the trash. Holiness is in front of us calling us to say 'yes' to the people we are committed to and responsible for. Holiness is being open to strangers and people we run into during the course of the day.

Holiness calls us to self-discovery and to know who we are and what gifts we have been given to bring to the table to share with those we meet along the way. Holiness calls us to have relationships. Holiness is what's going on inside of us.

Sometimes real holiness calls us to embrace, rather than run from our own pain and suffering, or to sit silently and be a friend to someone who must face theirs.

Sometimes holiness is an individual thing and it demands that we speak up for the oppressed when it is unpopular to speak up and when it seems nobody else in our community sees what we see. In the cases of Sister Ita Ford, Sister Maura Clark, Sister Dorothy Kazel, Jean Donovan and Sister Dorothy Stang, holiness led them to an ignominious death.

Bishop Ott was right about calling Calcutta "a very holy place." But first we have to find Calcutta—our own Calcutta. For most of us,

Calcutta is only a few inches away. It's the person standing next to you. It is that simple. Mother Teresa told people "you can find Calcutta all over the world if you have eyes to see—not only eyes to see, but eyes to look."

She said that we have to find holiness in the work that God has entrusted to us. "To each one of us, He has given a special gift," she said. "Maybe I can only peel potatoes, but I must do that peeling of potatoes beautifully. That's my love for God in action. It is not how much we do, but how much love we put in the doing. That's more important to almighty God and to us also," she said.

I came home from these trips thinking about the people we have in my city of Baton Rouge and people I know across the country. As I go about my business, I see many Mother Teresa's everywhere. Tim Basden helps out with the Little League for special needs children. Connie McLeod kept cancer victim Karen Short's memory alive when she took over the designing of the Polar Bear magazine. Dallas Ziegler and his wife Vicki brought food and comfort to an elderly woman whose family struggled to care for her; and every time the old woman's pilot light went out in her attic furnace, they hopped in the car, driving 15 miles through the snow, to re-light the pilot. While we may not always recognize it, Mother Teresas live among us.

Sometimes people in my town, who were already doing small things in service, would say to me, "I'm not in a position to go to Calcutta to volunteer to work with Mother Teresa." It was odd that these good people, who were doing good works in their everyday lives, felt inadequate.

Our culture doesn't allow us to believe that doing little things with great love counts towards greatness, or that doing our job with love is good enough.

Saints are supposed to be "ordinary people who do extraordinary things," according to Catholic theology. Yet Mother Teresa told people not to do extraordinary things. "Don't look for big things," she would tell people. "Do little things with great love."

In some strange twist, all the little ordinary things Mother Teresa

did added up to something extraordinary and it was extraordinary that she was so ordinary.

The person who reminded me most of Mother Teresa was a doorman I met in Calcutta at the Baptist mission. His job was to open and close the front gates for guests staying at the mission. He would emerge from a tiny shack inside the mission walls. There was no glass on the windows of the shack. There was one bench he used for napping. He walked about the mission barefooted. Every morning as I headed out the gates to join the sisters for work he greeted me with his big toothless smile. One morning he called out to me.

"Look!" he shouted.

I swung around.

"Milk," he said holding up a silver pail for me to see.

"I give to Mother Teresa for the poor."

The scene was absurd to my Western mind. There were thousands out there living on the streets. Yet, there he stood—armed with a big smile and a half a gallon of milk.

## CHAPTER SEVEN

# THE DARK NIGHTS OF THE SOUL

ALL TOLD, I MADE THREE trips to Calcutta. I spent eighteen days in 1991, thirty-three days in 1992 and thirty-two days in 1993. The 1993 trip was to do a "Come-and-See" with the Contemplative sisters. A Come-and-See is a short live-in at the convent for those interested in becoming nuns. It's an opportunity for people to live and work with the sisters to see if they feel called to live the life and do the work they do.

While this was my second "Come-and-See," I ended up making three of them; one in New Jersey, this one in Calcutta, and the last one I made in New York with the active branch of the order.

"A record! A record number of "Come-and-Sees!" taunted Baton Rouge Sister Juanita, finding humor in my struggles and bending over in laughter and teasing.

This particular Come-and-See had me staying at Saint John's Contemplative convent, during the Christmas holidays.

Only much later would I learn that Mother Teresa went calling on the Maryknoll community in 1972. Mother Teresa's contemplative branch was in its early stages of development. They requested to meet with Maryknolls contemplative sisters in order to know how the Maryknoll contemplatives remained integrated within the larger congregation of active sisters.

The entire Maryknoll Contemplative community gathered for that

moment. My great aunt, who then went by the name of Sister Marie Doelger, was introduced to Mother Teresa as the First Superior for the Maryknoll Contemplatives, having been installed in that position in 1932.

Because it was Christmas time in Calcutta, the sisters decided they were going to do a re-enactment of Mary and Joseph when they had to go looking for a place to stay for the night so Mary could give birth to Jesus. The sisters selected one nun and dressed her up as the Blessed Mother. Three other sisters were chosen to be the Wise Men. I was recruited to be Saint Joseph. The nuns dressed me in a robe with a covering for my head and supplied me with a Shepherd's hook to hold in my hand.

It was all kind of harmless and fun until we headed out the Saint John's Convent door and down the very busy public street to parade to the Mother House located at 54A AJC Bose Road. Calcutta was less than five percent Christian. I wondered what all the Muslims and Hindus were thinking as they watched us. When we finally got to the Mother House, we climbed some stairs and there the nuns told me to knock on Mother Teresa's bedroom door and when she opened it I was to say, "There is no room at the inn. May we stay here for the night?" I felt mortified that I would knock on Mother Teresa's bedroom door dressed up like Saint Joseph. The nuns assured me it was ok and that this was their Christmas tradition.

I did it.

There I stood outside Mother Teresa's bedroom door—dressed up like Saint Joseph with Mary at my side, a small band of nuns behind us.

When Mother Teresa opened her door, I said, "There is no room at the inn. May we stay here for the night?"

Everyone had a good laugh and she let us in. Mother Teresa's bedroom was small and primitive looking with only a single bed and a small wooden desk. There was one vertical window and a plastic toy airplane hung from it. Other than that, there were no fancy decorations and no awards or art hung on the walls—not even the Nobel Peace Prize was in sight. Mother Teresa lived in solidarity with the poor whom she served. Her bedroom reflected that.

While the nuns in Mother Teresa's contemplative branch prayed a good part of the day, most days they prayed two hours at a stretch. When I arrived at Saint John's my mind kept taking in the newness of everything, making it difficult for me to pray two hours at a stretch.

During prayer time in the sister's small chapel at Saint John's, I listened to the sounds on the street...the honking horns mostly. I studied the architecture of the chapel that would become my home for the next month. I got up and went to the bathroom as often as I could without drawing attention to myself. I observed the tree tops out the two windows behind the altar. I counted the altar candles and watched their flames sway about in hypnotic moves as we prayed on our knees before the Eucharist. The longer candlewicks burned through their fuel faster, but produced a larger flame that danced much taller than the flames produced by the shorter wicks. Like a majestic ballerino, the taller flames appeared at times to be reaching for the heavens, only to be blown about by the sudden movement of air in the room. That's when the flames would find a fulcrum at the tip of their wicks, and like the sisters gathered in the room, the flames took a bow.

I studied the expressions on the faces of the sisters while they prayed and took note of how they sat. I noticed each sister held her rosary differently as she moved her beads across her fingers. Some held their beads more cupped on the inside of their hands while others let the beads weave and flow around the outsides of their fingers. Some pushed their fingers into a peak that reached toward the sky, while others let their fingers wrap into a gnarled ball. Most of them had long ago settled on a position. In fact, I could probably have identified each sister based on how she held her rosary. I fidgeted and squirmed a lot as I imitated each sister, trying to find what worked for me.

Because I knelt there praying while my camera lay in its bag upstairs, I mourned over the shots of the sisters I missed. But lack of equipment didn't stop me from taking pictures. I began moving about the chapel, photographing the chapel in my mind, picking optimal angles, finding good lighting, visualizing the results.

I even flew around the room, hovering over the sisters' heads shooting aerials of their heads, their hands and their feet. Suddenly my

mind blew the roof clear off the small chapel. I saw myself hovering over the building in a helicopter creating amazing images of the white forms and patterns praying below.

After two weeks of this…thinking…listening…counting…watching the candles dance about…flying around the room and repeatedly photographing everything in sight in every conceivable angle, my mind began to quiet. Running out of new material to juggle, my body got comfortable too and settled down in some positions. We were all barefooted and that, of course, was wonderful.

I finished experimenting with how to hold my rosary and settled on a position, when it happened, when I learned a different form of prayer, a deeper prayer, contemplative prayer.

When there was nothing left inside of me, no more new thoughts to reprocess, no more new sounds to hear, no more new patterns to count, no more pictures to take, my mind seemed to finally forget about my body and about all the physical demands that held me captive and distracted. My mind, or was it my soul, took me to new places I had not visited before. While my senses were aware of my surroundings, at any moment I could have gotten up and gone to the bathroom, my whole being was stilled. I was quieted. I was dulled to the world. I was in some wonderful space where thinking stops and there is no new knowledge… and I just was.

But in that newly discovered contemplative prayer space, I didn't talk to God as such, nor did I recite my prayer list asking Him to fix my relatives or give me things. I just enjoyed Him. I was knowing Him and he was knowing me.

When I was a little girl my Dad would take me with him in the car after dinner to go get chocolate ice cream for the whole family. On these little trips to the store, filled with quiet moments where neither of us would utter a word, I loved my Dad so much that I couldn't speak.

It was just the two of us. I had him all to myself. We would just sit there, driving in the car to the store, enjoying each other and not speaking all the way there and all the way back. This contemplative prayer experience reminded me of that. It was just a simple "being," not asking, not talking, or even doing…just being.

Suddenly the two hours of prayer were over. And I hadn't even gotten up to go to the bathroom. The hours had gone by so slowly before. Now I didn't want them to end. When I got up I didn't speak. I didn't want to. I noticed I got some looks from the sisters. They knew where I'd been.

The great contemplative, Saint John of the Cross (a Spanish mystic priest from the 1500s) once wrote about this type of prayer or high contemplation in his poem *The Living Flame of Love.*

*I entered into unknowing,*
*Yet when I saw myself there*
*Without knowing where I was,*
*I understood great things;*
*I will not say what I felt*
*For I remained in unknowing*
*Transcending all knowledge*

*That perfect knowledge*
*Was of peace and holiness*
*Held at no remove*
*In profound solitude;*
*It was something so secret*
*That I was left stammering,*
*Transcending all knowledge.*

*I was so 'whelmed,*
*So absorbed and withdrawn,*
*That my senses were left*
*Deprived of all their sensing,*
*And my spirit was given*
*An understanding while not*
*Understanding.*
*Transcending all knowledge.*

*He who truly arrives there*
*Cuts free from himself;*

*All that he knew before*
*Now seems worthless,*
*And his knowledge so soars*
*That he is left in unknowing*
*Transcending all knowledge.*[7]

I learned a lot from the contemplative sisters besides how to pray. I learned that God sometimes hides from us. He plays with us. And that we sometimes find ourselves chasing after Him like a wounded lover who can't get what they want. I guess that's why I had to do so many Come-and-Sees. Maybe God was playing with me. In his poems Saint John of the Cross wrote about these things, about deep contemplative prayer and about having to go searching for God like we would a lover. In *The Spiritual Canticle* John of the Cross writes:

*Where have you hidden,*
*Beloved, and left me moaning?*
*You fled like the stag*
*After wounding me;*
*I went out calling for you,*
*But you were gone.*

*Shepherds, you who go*
*Up through the sheepfolds to the hill,*
*If by chance you see him I love most,*
*Tell him I am sick, I suffer and I die*

*Seeking my love*
*I will head for the mountains and for watersides;*
*I will not gather flowers,*
*Nor fear wild beasts;*
*I will go beyond strong men and frontiers.*

*O woods and thickets*
*Planted by the hand of my Beloved*

*O green meadow,*
*Coated, bright, with flowers,*
*Tell me, has he passed by you?*

*Pouring out a thousand graces,*
*He passed these groves in haste;*
*And having looked at them,*
*With his image alone,*
*Clothed them in beauty.*[8]

Most people don't know these love poems to God by Saint John of the Cross. Many Catholics don't know about them either.

He also wrote poems about "the dark night of the soul." I first learned about "the dark night" from Sister Ancy, who at the time was the Regional Superior for Mother Teresa's contemplative group in the United States.

When Sister Ancy spoke about the dark night, she got more serious than I ever knew her to be. Seriousness normally didn't afflict Sister Ancy. In fact, one time her adventurous ways led her to try walking on water over a dare from another sister.

*Sister Ancy walking on water from a dare from another sister.*

We were visiting someone's home back East. Out in the back yard a huge tarp covered their swimming pool, keeping the leaves off for the winter. One of the sisters dared Sister Ancy to walk on water...to walk across the tarp covering the pool.

Accepting the dare, she headed for the tarp. When her first step came down, that whole side of her body started sinking. Her second step rescued her by popping her descending side back up. But now the collapsing water under the tarp sucked that side down. Sister Ancy lifted her habit and picked up her speed in order to maintain control. She moved side-to-side like a jack-in-the-box on a spring, teetering to the

left and then to the right. The other sisters screamed and cheered as she made it all the way across the pool. Soon, they joined in and everyone was walking on water.

Sister Ancy taught me that a soul could go on for years feeling abandoned by God and feeling alone in the desert—or simply not feeling like God is around, or cares or even exists. When this happens, God is there, she told me. But you're in the dark night. So you don't feel God or even think He is there.

There's not much you can do about it, she said, the dark circles under her eyes underscoring the seriousness of it all. This aridity can seem like it will never end and no amount of human effort seems to end it. It doesn't mean you did something wrong. The dark night just happens to people. Nobody can rescue you. You just have to wait it out and try to keep your wits about you. One day you simply come out of the painful passage as quickly as when you slipped into it, and often the soul comes out of it more illuminated and you a better person.

I was glad to get this practical information from a person who devoted her whole life to spiritual things, a holy person. I decided that should the Dark Night find me one day, I would try not to be defeated by it, or take it personally and become bitter towards God. I felt more prepared, fearing that all this searching I was doing would one day end and that the dark night of the soul would surely find me.

I was right. It did. But not yet.

My bedroom at Saint John's convent was at at the top of the stairs, and down a makeshift hallway, and to the right. The tiny space barely fit my suitcase, my backpack and the small cot that filled my room.

Only a few days into my Come-and-See I developed a ritual of waking up during the middle of the night needing to go to the Western-style bathroom downstairs where I could sit over a hole instead of squatting over one. I groped my way through the dark convent, trying not to wake the sleeping nuns. When I reached the downstairs area I passed through the dining room that contained the long picnic table we all took meals on. Mosquito netting hung from the ceiling draping the entire table, I assumed it protected our dry food from the mice. Every morning a few sisters would walk to the nearby street vendors to buy

fresh food for the day's meals. Since we had no refrigeration, anything perishable had to be eaten by the end of the meal, but the dry foods were stored.

When mealtime came, I put a generous portion of mango chutney—a spicy Indian condiment—on my rice. As good as the meal was, I developed a persistent craving for cookies. I wondered if the sisters kept cookies on the picnic table under the heap that was being protected by the nets. Several times on my forays to the bathroom, I resisted the urge to rummage through the pile on the table for any cookies under the mosquito netting.

I had been caught stealing cookies once before and the unpleasant experience was still with me. Back on Hilltop Farm, Billy Moffett's mom always kept her cookie jar full of chocolate cookies, the ones that had a nice cream in the middle. In our home, the cookies never made it into a jar. Whenever I visited Billy's home, my mind always got to thinking about that jar full of cookies. Sometimes Mrs. Moffett would offer Billy and me a few cookies; most of the time she didn't think about it. One day, Billy's mom left us alone in the house as she worked in her garden out back. Using a kitchen chair, we lifted our 5-year old bodies high enough to get the jar and bring it down to the floor underneath the kitchen table. We hardly got a cookie in our mouths before Billy's mom came in and caught us, hands full of cookies.

Soon after I abandoned my thoughts of locating where the cookies were stored in the sisters' dining room, we got the news that some sisters were rushed to the hospital and that they needed our prayers. Sister Fatima, the mother superior of the house, informed us that we would pray round-the-clock for the sisters. I took the 3 a.m. shift. When my shift was over at 4 a.m., I was to wake Sister Amalie for her shift.

"Sister Fatima," I said. "Tell me where Sister Amalie sleeps and I'll wake her when it's her turn."

"Marie, we're short of beds and she sleeps on the picnic table," in the dining room.

It was Sister Amalie under that mosquito netting, not food. I never confessed that I almost searched Sister Amalie for cookies.

A short time into the Come-and-See, Sister Fatima, the Mother

Superior of the house, asked me if I wanted to travel with her to their contemplative convent in Chinchura for a few days. It was less than a half-day journey if we went by train, boat and rickshaw. First we boarded a train, taking the Sealdah Railway line. Sister Fatima explained to me that it was from this very train station that years ago Mother Teresa received what she described as a call to serve the poor. She was riding a train out of the Sealdah station to Darjeeling at the time when the call came to her.

Our train dropped us out onto the banks of the Hoogly River where we next rode a ferry stuffed so full of people that we had to be seated in the belly of the boat, the engine room. There we sat, in a semi-circle, seated around the big noisy engine that sputtered diesel fumes as it powered us across the Hoogly. Once we stepped out of the boat, our final leg was to catch a ride in a rickshaw into Chinchura where we spent a few days at a small contemplative convent there.

One of the first jobs I was given to do in Chinchura was to go up on the flat rooftop of our convent where some grains were drying in the sun. Another sister and I picked the sticks and stones out of the grains and then swept the remains into a cloth bag. Next we walked the bag over to the local wheat grinder where we stood watching him as he ground it all up into flower right there in front of us. That evening the sisters made chapati from the flower—an unleavened flatbread. Each Chapati got toasted over a burner for a few minutes until golden brown spots appeared.

Every time I made a trip to Calcutta, I got a terrible sinus infection. I didn't get worms or parasites like some, I always got sinus problems. About mid-way into my Come-and-See I developed a bad infection. This time it went straight into my ears give me a painful ear ache. In Calcutta there was so much suffering on the streets, it seemed absurd that I would pay much attention to it. Thinking I could neglect myself because other people suffered on the streets, made matters worse for me and the infection took ahold giving me two throbbing ear aches.

That afternoon I slipped upstairs to lie down. There I lay, holding both hands over my ears trying to staunch the pain when Sister Fatima looked in on me. I told her about the earache.

Sister Fatima asked me, "Marie, can I pray for you?"

"Yeah," I replied, barely able to speak.

She said a little prayer of healing over me, then she asked me to repeat after her: Mary, Mother of Jesus, be a Mother to me now."

I prayed, "Mary, Mother of Jesus, be a Mother to me now."

"Say it again." Sister Fatima said.

Again I prayed aloud, "Mary, Mother of Jesus, be a Mother to me now."

"Marie, say it again," Sister Fatima said.

For the third time I prayed, "Mary, Mother of Jesus, be a Mother to me now."

Sister Fatima made a little sign of the cross on my forehead with her finger and next she asked me if I would like to go fall asleep with Mother's (Mother Teresa) rosary in my hand.

"Yes" I said, now smiling.

She disappeared and came back with it a few moments later.

The next morning when I woke the pain in my ears was completely gone and all that remained of my infection was some residual sinus congestion.

It never occurs to me to pray for help when I get sick, because I can call my internist instead, or I get help from friends. Even if it's in the middle of the night, I can always get a doctor on call. Why would I call on God?

Being in a contemplative convent gave me plenty of time to reflect on that experience. It made me realize the poor have a different kind of relationship with God than those who have abundance. They call on God for things we would never think to call on God for.

We are never told why God has a special love for the poor. But this regard is so important that Jesus took on the lifestyle of a poor person and when Mary was pregnant, she and Joseph were essentially desperate emigrants begging for help from strangers.

Before I began this Come-and-See, I delivered a package for someone from the United States to a Calcutta man who lived in the slums. When he learned I had traveled to Calcutta by myself to be with the sisters, he invited me to dinner with him and his wife. After telling

the contemplative sisters about the invitation, they warned me not to eat their food.

"Don't eat their food, "they said. "The poor will feed you everything they have, and they will go hungry the next day."

Sure enough, I arrived at their home for dinner stepping into the doorway of what appeared to be a one-room, dirt-floor hovel. There were no chairs or dining room table, so I sat on an elevated full-sized mattress, covered nicely with blankets and a few pillows. The wife squatted over a tiny fire fueled with dried dung. The coals from the dung heated a small tin holding water for our tea she was about to pour.

While I was the honored guest, there were two other guests, a man and his daughter who came to meet the American. The man sat on the mattress next to me. My host's wife had prepared what looked like small vegetable pies and Indian sweet breads and other finger foods that I didn't recognize. Spices filled the tiny space with the aroma of cumin, cinnamon, turmeric, and cardamom.

The words, "they will give you everything they have," played in my head, reminding me what an amazing Christmas this was. The man and his wife took me in because I came to Calcutta alone, and they wanted to share their food with a stranger.

I eagerly took the tea and one of the small pies telling them I could not eat anything else because I was having some medical problems. I could have easily eaten all the pies on the tray, but I didn't want to wipe them out. They pushed hard to get me to take more. I held my ground. When the meal was over, I didn't run to one of the many restaurants in the slums to fill my stomach, instead I went back to my room hungry that night and lay in my bed thinking about it all.

Pope Francis talks to us often about giving to the poor, not from our excess, but from what is necessary for our own wellbeing.

He says in his sermons that the theology of poverty is the heart of the Gospels. It is a mystery why Christ lowered himself, allowed himself to be humiliated and to live like a poor person in order to reach us. The Pope even said in one of his morning meditations that "if we were to remove poverty from the Gospel, nothing would be understood of Jesus' message."[9]

While we are never told why God loves the poor so much, it is clear that He does. In the Bible the references to the poor contain some of the strongest language. The Bible says things like "It is easier for a camel to pass through the eye of a needle, than for one who is rich to enter the Kingdom of God."[10] Should you not be kind to the poor, or should you oppress the poor, or refuse help to the poor, there exist a multitude of passages to condemn your behavior.

In Ezekiel 16:49 for example we find: "Now look at the guilt of your sister Sodom: she and her daughters were proud, sated with food, complacent in their prosperity, and they gave no help to the poor and needy."[11]

Mother Teresa went around telling people that Jesus comes to us in a disguise, a distressing disguise, "the distressing disguise of the poor." The idea was, if a person wanted to find God, go be with the poor.

For decades in the South we've been growing poor people faster than you can harvest sugar cane. Louisiana always sits at or near the top on lists of states which have the greatest number of people falling below the poverty line. I began to see that people are indeed "made" poor by actions occurring right here in our State Capitol and down at the Metro Council where laws are passed. It's not just confined to the developing world anymore.

It's easy to understand the economics of the feudal system in Brazil that Sister Ellen spoke of. But in the modern world, how we make people poor looks different. People are made poor, and even bankrupt, when they have to fork over thousands of dollars for life-saving drugs that, in more compassionate times, cost less than a monthly water bill. Allowing large companies to gobble up smaller ones erodes the competition that used to hold back price gouging. It is a species of oppression when in the name of "patient safety" folks are made poor because laws stop them from reaching across borders to get the exact same medicines at affordable prices.

Making people poor happens when systems of government generate revenue through sales taxes rather than income taxes, thus not taking into account how imbalanced the burden would be on lower-income

people. People are made poor when cities implement fines, fees and bail in a way that disproportionately punishes the poor over the rich. The growing use of technology to catch people, intensifies all this making people shell out more and more money as time goes on. Often these practices are mere preditory revenue-raising schemes imposed on a fragile population. It drives the poor farther down into a kind of modern day debtors' prison.

While Sister Dot ended up on a death list for her advocacy, in Louisiana we have a different type of "Death List." If you have a child so profoundly handicapped that they can't even pick up a glass of milk, you register to be on a waiting list to get assistance from the State. Most families wait more than nine years on this list. Some call the list "The Death List" because the doors for services to a new child only open up more quickly when a child already in the program dies. However, even when a child dies, their slot has to get refunded before it can be passed on. Recently the House Appropriations Committee advanced a bill to gut the program.

For families earning low wages, the wait on the Death List is devastating and even Life-threatening to the child. Divorce rates are high among these families. Despite the absolute moral obligation to help care for our most vulnerable people, our governmental system places more importance on providing assistance to the rich. The local paper, the *Morning Advocate*, reported that a few years ago tax breaks for six programs to big business cost the state $1.08 billion, more than double the entire amount budgeted for all disability services statewide. People are made poor every day while corporate welfare checks around the country are printed at alarming rates

People can be made poor when school systems aren't given resources to educate properly, or when the cost of college tuition prevents a young couple from ever owning a home or saving for retirement.

If we would but view things from another person's stance, we could change some of the systems that are making people poor and sending some to prison. With the decline of the middle class, it's never been more critical.

During the last recession many families lost their homes because

they couldn't make payments. Why not develop loan instruments that have "crisis periods" built in. In effect, loan borrowers could pay a little extra each month, giving them crisis credits, whereby if they lost a job, or couldn't work because of a serious illness, they could be excused from making payments and the life of the loan would automatically be extended without unaffordable fees.

We can bring change if we will but look at the ways we make people poor.

While I never joined the contemplative sisters, nor the active branch of the Missionaries of Charity, or any other group for that matter, that dark night Sister Ancy spoke about did come for me. It came when I had to finally end my teenage dreams of becoming a nun. My dark night came when I was in Nicaragua doing some pro-bono work for the Saint Joseph Sisters. I went to visit Mother Teresa's sisters nearby and was napping on a cot at their convent when one sister came in and woke me to give me the news that my good friend Sister Sylvia was dead. Sister Sylvia was at the wheel when the minivan she was driving blew a tire on Interstate 66 in Virginia. The van flipped over and over killing Sister Sylvia on the scene. Later Sister Kateri died at the hospital from her injuries, leaving an injured lay volunteer as the sole survivor of the crash.

As fate would have it, Sister Ancy happened to be visiting that same Nicaraguan convent at the time. We both cut our trips short, and traveled together, catching a plane out of Managua and into New York to be there for the funeral.

While Sister Sylvia died in July of 1996, a year later, at the age of 87, Mother Teresa died of heart failure while in Calcutta.

It was time to stop running around the world and time to end my dream to be a nun. It had gone on long enough. With all those Come-and-See's now behind me and important people in my life now dead, with my family dispersed from one end of the country to the other, unable to unite or heal itself from its own tragedies, my dark night came. Like a train rushing down the tracks, it came. I thought I was all alone when it came, until I realized that my beautiful friends and clients, and what was left of my family, loved me and wanted to be part of my nomadic life.

It was time to buy a house, settle down, whatever that meant, and try to be normal.

Mother Teresa had a custom that if she wanted something, like a building or a house for a project she was about to start, she would kiss a miraculous medal and throw it into the bushes and ask God to give her the building. The sisters who told me she did this swore that it worked.

Since I had a small handful of miraculous medals she had kissed and given to me, I decided to throw one into the bushes at a house I found for sale on Cloverdale Street, the same street friends of mine lived on. I kissed the medal, said a short prayer asking God to give me the house and threw the medal into the bushes.

The next day, I learned a young couple bought the house. It shook me up and I swore I would never waste a good medal like that again, reasoning it probably only works for Mother-Teresa types. My friends were upset that I wasted a good medal and wanted to go back there and dig it out of the bushes. I left it there thinking the couple might need it.

A few months passed when I found myself sitting next to a realtor in an Arts Council meeting. After the meeting I asked the realtor if he had any homes in the Downtown area. He showed me what soon would become my home.

When I bought my home, a duplex, there were tenants renting out both the front and back. I told the tenants that if they cleaned out everything and did not leave me a mess when they moved out, I would give them back their full deposit from the previous owners. They did just that. They swept, and mopped and cleaned and removed all their belongings. Both units were spotless, except one tiny item that was left behind by the renters in the front. There in plain view, hanging on a window latch, was a chain that held a miraculous medal.

As silly as it was, even though death and loss hung over my head, finding that little miraculous medal gave me all I needed to know that I was not alone in this world. No telling how many medals Catholic have. One web site features over 4,000 different medals in one category. All the same, it gave me goose bumps to see a miraculous medal hanging there.

The house I had bought was an old craftsman bungalow built in the

mission style in 1919 by Victor Sachse. Time had broken and wounded the old house. Time was doing the same to me. My dark night arrived. There was no stopping it, and no getting out of the way. In my mind I saw Sister Ancy and those big brown eyes and that serious face, telling me the dark night is ok. It doesn't mean God is abandoning you. It just feels like it.

My new house had 120 windows that were painted shut. Most of the glass in the windows was the original lead. This house sat in the middle of the downtown's historic district and one year before it was built, Huey Long built Louisiana's Art Deco State Capitol down the street. I learned that the city's' most popular parade, the Spanish Mardi Gras Town Parade, passed right by my porch.

Renters had their way with the house and at one time it even served as a half-way house for alcoholics. When bath water emptied from the claw tub, all the water poured into the basement from the leaking plumbing. Even though the house passed inspection, I discovered active termites in the kitchen. It had well over 15 trash cans, buckets and pots and pans catching the rain-water which poured into the attic from the leaking clay-tile roof. The renters in the back had been turning on the kitchen faucet with a wrench. The stench of gas permeated the air as gas leaked out of the pipes: one leak in the basement, one in the attic and one outside. When I called a guy to come repair the two heater units for the winter coming on, instead of fixing them, he immediately condemned them, telling me the heat exchangers were cracked. I went my first winter without heat. That summer both air conditioners broke.

I began to fix that house and scrape those windows. For thirteen months I scraped layers of paint off the windows. The windows were arranged in sets of 6 and it would take me 38 hours to get the paint off of one set.

When I finished scraping, some Saint Joseph Sisters, Sister Kathleen Bahlinger and Sister Lory Schaff, came over and helped me paint. The sisters were good painters and in no time we got the dining room and entrance done. Somehow I knew that when it was all done, my dark night would go away, but that it would go away when it finished doing its work in me. So I just let myself be and because of Sister Ancy's

wisdom, I didn't fight it, I didn't numb it, I just embraced the pain of it all.

Years ago the break in the family disconnected me from a powerful life force. That severing changed my path forever. Reconnecting that break led me down amazing trails as I struggled to get back to my roots and my family.

In 2007 I flew into New York City, rented a car, and drove up to Maryknoll in Ossining, New York where my great aunt, Sister Mary Magdalen, first joined the order and where she eventually passed away. I wanted to walk on the grounds where she walked and meet her sisters. I hoped to also be allowed to look at their archives. When I knocked on the convent door that afternoon, I was a total unannounced stranger, yet Sister Genie Lorio did what you would expect a Maryknoller to do, she welcomed me in, fed me dinner, put me up for the night and the next morning made sure I got to meet with some of the sisters who lived and worked with my aunt.

While a vocation to religious life can call some to pick people up off the streets—the dying and the destitute, giving free services to the poorest of the poor, others in religious life ask, "Why are these people made poor? How can we bring awareness of the structures that cause this and solve problems in a way that don't destroy people?" While some people seek to be a reflection of God during times of war and oppression or great darkness, others bring medical care to that same group. These are separate callings. The callings lead to different styles that travel down some of the same paths.

Then there is the beautiful calling most of us have, to simply find Calcutta in our own homes, in our own families, and then in our own cities and institutions. Are we making people poor? Do we have ears to hear? Do we have the eyes to see it? Do we have the courage to look?

The Church also calls people to tell these stories to others in pictures and in words. As I gathered together information for this book, I had to stop and take a break, walking around in silence, like I was on a retreat or something. The deaths of the sisters and the generosity of others overwhelmed me. Silence allowed me to process the notion of the

possibility that one person can have so much good inside of herself. All of us have this common vocation, to have so much goodness inside of us.

Before I returned from my short trip up to Maryknoll, I bought a couple of Maryknoll hats to wear for when I'm out pruning the trees at my camp on the Atchafalaya River. I've planted more than three hundred trees after hurricane Gustav knocked down fifty. Even though there are more trees than I could ever prune, each tree I stop at gets my full attention and care. Whenever I make a big cut to a limb, I seal the wound with some goop I carry with me. I walk around smiling. The dark night never destroyed me…not even close…there were too many life forces (nuns) picking me up along the way.

*Marie Bissell Constantin*

# SOURCES

Eileen Eagan. *Such a Vision of the Street.* Doubleday & Company, Inc. 1985.

Jeanne Evans, Editor. *"Here I am, Lord" The Letters and Writings of Ita Ford.* Orbis Books, Maryknoll, New York. 2005.

Penny Lernoux. *Hearts on Fire The Story of the Maryknoll Sisters.* Orbis Books, Maryknoll, New York. 2000.

Adel S. Paroni. *Peter Doelger a Remembrance.* Exposition Press, Inc., Jericho New York. 1972.

www.fofah.com Friends of the Farm at Hilltop.

# END NOTES

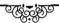

1. Nun—The term "nun" is technically reserved for women religious who live a contemplative or cloistered life. However, in this book the terms "nun" and "sister" are used interchangeably. They are, however, two different ways of life

2. Richard Rodgers and Lorenz Hart wrote *Blue Moon* in 1934. It became a hit in 1949 when Billy Eckstine and Mel Torme recorded it.

3. Taken from one of Archbishop Oscar Romero's last homilies before he was martyred on March 24, 1980 while saying mass at the chapel of the Hospital of Divine Providence in El Salvador.

4. Maria Harris. *Proclaim Jubilee! A Spirituality for the Twenty-First Century*. Westminster John Knox Press, page 72.

5. Jeanne Evans, Editor. *"Here I Am, Lord," The Letters and Writings of Ita Ford*. Orbis Books, Maryknoll, New York, page 185.

6. The *New American Bible*. World Catholic Press. A Division of Catholic Book Publishing Corp. July 27, 1970. Page 1054.

7. Translated by Kieran Kavanaugh, O.C.D.; Otilio Rodriguez, O.C.D. *The Collected Works of St. John of the Cross. The Living Flame of Love*. Institute of Carmelite Studies, ICS Publications. 1991, Page 53.

8. Translated by Kieran Kavanaugh, O.C.D.; Otilio Rodriguez, O.C.D. *The Collected Works of St. John of the Cross. The Spiritual Canticle*. Institute of Carmelite Studies, ICS Publications. 1991, Page 44.

9. Pope Francis, Morning Meditation in the Chapel of the Domus Sanctae Marthae, *Wealth and Poverty*, Tuesday, June 16, 2015, © Libreria Editrice Vaticana.

10. *The New American Bible*. World Catholic Press. A Division of Catholic Book Publishing Corp. July 27, 1970.

11. *The New American Bible*. World Catholic Press. A Division of Catholic Book Publishing Corp. July 27, 1970. Page 886.

CPSIA information can be obtained at www.ICGtesting.com
Printed in the USA
LVOW11*1005040916

503160LV00001B/5/P